THE PRINTS OF HAMILTON

A nostalgic view of the Ambitious City

Gary Evans

Published by
North Shore Publishing Inc.
Burlington, Ontario

Canadian Cataloguing in Publication Data
Evans, Gary W., 1942-
The Prints of Hamilton
ISBN 1-896899-09-9

1. Historic Scenes - Ontario - Hamilton
2. Old Photographs - Hamilton - Ontario
3. Hamilton (Ontario) Description - Views
I. Title
II. Author

Cover design: Helen Witkowski

Printed and bound in Canada

First printing, 1999
Second printing, 2004
Third printing, 2007

Contents

Contents

Preface

There's something ever so appealing to the city at the Head of the Lake. It has been labelled the Steel City, and indeed it has thrived as a result of the steel industry ever since that day so long ago when the formation of the first steel plant was announced. But Hamilton is more than heavy industry.

It is a city of beauty; a city of magnificent scenic sights; a city rich in history; a city full of wonders, wonders that have attracted so many photographers over the years.

The Prints of Hamilton paints a unique portrait of the city through the lens of a camera; not just one camera, but many cameras through the ages.

Since the first photograph of Hamilton was snapped back in the mid-1800s, countless photographers have documented the growth of the city, from the ever changing streetscape in the downtown core to the magnificent vistas from the mountain to the shifting sands along the beach front to its industrial heartland.

That so many photographs have captured the city on film over the decades is one thing, but for so many fascinating photographs to have survived the passage of time is something else.

The Prints of Hamilton is but a snapshot of those collections, but yet a fascinating look at Hamilton dating back to a time of dirt roads, wooden sidewalks, and the horse and buggy.

But there is a lot of nostalgia in this collection of old Hamilton. Old negatives have revealed images of a changing city, a city where a famous fountain is demolished, replaced by a modern version, and then replaced with an 1860s replica.

Other photographs show the results of urban renewal, reveal old buildings long gone, streets which have been re-aligned, and incline railways long replaced by cars and buses.

A series of aerial photographs document the vast transformation of the city, while other pictures show the working class of a different era, or a train crash just off the downtown core.

As you leaf through these pages of time, a Hamilton of another era will come alive. A Hamilton filled with history, a Hamilton rich with tradition, a Hamilton through the eyes of yesterday's photographers.

Acknowledgements

A book such as *The Prints of Hamilton* doesn't just happen.

There are many people needed to push the concept past the idea stage and into the realities of publication.

Once the idea for the book was generated, photographs had to be found and through the support of many people, a fascinating cross-section of Hamilton has been captured in this book.

Thanks must be offered to Brian Henley and the staff of the special collections department at the Hamilton Public Library for searching out many of the photographs found in this book, and for providing access to years of old negatives, a collection of fascinating negatives dating back into the 1950s and '60s from the Hamilton Spectator collection.

Special thanks go out to Christine Bourolias, reference archivist, special collections, Archives of Ontario, who provided key links to old Hamilton photographs within the archives' collection.

Ross Taylor once again deserves a word of thanks for his assistance in dating many of the early photographs, and while it was not always possible to secure an exact date, his assistance allowed us to establish a time frame for this collection.

And to all those other people who provided photographs, or key information about a picture, I offer my thanks. Your assistance made this book possible.

Gary Evans

Picture credits

The photographs in this book should be credited as follows:

9 - The Hamilton Spectator
10 - Special Collections Department
 Hamilton Public Library
11 - NSP Collection
12 - The Hamilton Spectator
13 - The Hamilton Spectator
14 - Special Collections Department
 Hamilton Public Library
15 - The Hamilton Spectator
16 - The Hamilton Spectator
17 - The Hamilton Spectator
18 - The Hamilton Spectator Collection
 Hamilton Public Library
19 - The Hamilton Spectator
20 - Special Collections Department
 Hamilton Public Library
21 - Special Collections Department
 Hamilton Public Library
22 - Special Collections Department
 Hamilton Public Library
23 - Special Collections Department
 Hamilton Public Library
24 - Special Collections Department
 Hamilton Public Library
25 - The Hamilton Spectator
26 - The Hamilton Spectator
27 - The Hamilton Spectator
28 - Archives of Ontario (ACC2728 ST106)
29 - Archives of Ontario (C285-1-0-4-56)
 Courtesy: Northway-Photomap Inc.
30 - The Hamilton Spectator
31 - The Hamilton Spectator
32 - The Hamilton Spectator
33 - The Hamilton Spectator Collection
 Hamilton Public Library
34 - The Hamilton Spectator
35 - The Hamilton Spectator
36 - Special Collections Department
 Hamilton Public Library
38 - The Hamilton Spectator
39 - Special Collections Department
 Hamilton Public Library
40 - The Hamilton Spectator
41 - The Hamilton Spectator Collection
 Hamilton Public Library

42 - The Hamilton Spectator Collection
 Hamilton Public Library
43 - The Hamilton Spectator
44 - The Hamilton Spectator
45 - The Hamilton Spectator
46 - The Hamilton Spectator
47 - Cunningham Collection
 Special Collections Department
 Hamilton Public Library
48 - NSP Collection
49 - The Hamilton Spectator
50 - Special Collections Department
 Hamilton Public Library
51 - Special Collections Department
 Hamilton Public Library
52 - Archives of Ontario (ACC 2728 ST110)
53 - The Hamilton Spectator
54 - Archives of Ontario (ACC2728 ST117))
55 - Archives of Ontario (ACC2728 ST104)
56 - The Hamilton Spectator
57 - The Hamilton Spectator
58 - Cunningham Collection
 Special Collections Department
 Hamilton Public Library
59 - Hamilton Public Library
60 - The Hamilton Spectator Collection
 Hamilton Public Library
61 - Special Collections Department
 Hamilton Public Library
62 - Special Collections Department
 Hamilton Public Library
63 - Hamilton Street Railway Archives
64 - Hamilton Street Railway Archives
65 - Hamilton Street Railway Archives
66 - Hamilton Parks Board
68 - Hamilton Parks Board
69 - Ross Taylor
70 - Archives of Ontario (RG-56-11-0-2.46-1)
71 - Archives of Ontario (RG56-11-0-2.31-1)
72 - Special Collections Department
 Hamilton Public Library
73 - The Hamilton Spectator Collection
 Hamilton Public Library
74 - The Hamilton Spectator Collection
 Hamilton Public Library
76 - The Hamilton Spectator Collection
 Hamilton Public Library

77 - Special Collections Department
 Hamilton Public Library
78 - The Hamilton Spectator
79 - The Hamilton Spectator Collection
 Hamilton Public Library
80 - The Hamilton Spectator
81 - The Hamilton Spectator Collection
 Hamilton Public Library
82 - The Hamilton Spectator Collection
 Hamilton Public Library
83 - The Hamilton Spectator Collection
 Hamilton Public Library
84 - The Hamilton Spectator
85 - The Hamilton Spectator
86 - The Hamilton Spectator Collection
 Hamilton Public Library
87 - The Hamilton Spectator Collection
 Hamilton Public Library
88 - NSP Collection
89 - The Hamilton Spectator
90 - Special Collections Department
 Hamilton Public Library
91 - The Hamilton Spectator
92 - The Hamilton Spectator
93 - Special Collections Department
 Hamilton Public Library
94 - The Hamilton Spectator
95 - The Hamilton Spectator Collection
 Hamilton Public Library
96 - Special Collections Department
 Hamilton Public Library
97 - Special Collections Department
 Hamilton Public Library
98 - Archives of Ontario (C30-1 ES25-308)
 Courtesy: Northway-Photomap Inc.
99 - The Hamilton Spectator
100 - The Hamilton Spectator Collection
 Hamilton Public Library
101 - The Hamilton Spectator Collection
 Hamilton Public Library
102 - The Hamilton Harbor Commission Archives
103 - The Hamilton Spectator Collection
 Hamilton Public Library

Monumental approach.

When this photograph was taken from the promenade around the top storey of Hamilton's new city hall in 1960, then mayor Lloyd Jackson suggested that the narrow street running north from Main could be transformed into a monumental approach to the new civic building. At that time, Park Street was one of many feeder streets, housing numerous commercial and retail establishments on the edge of the downtown core. Today, much of the area seen here is home to Hamilton Place, the convention centre, and Jackson Square.

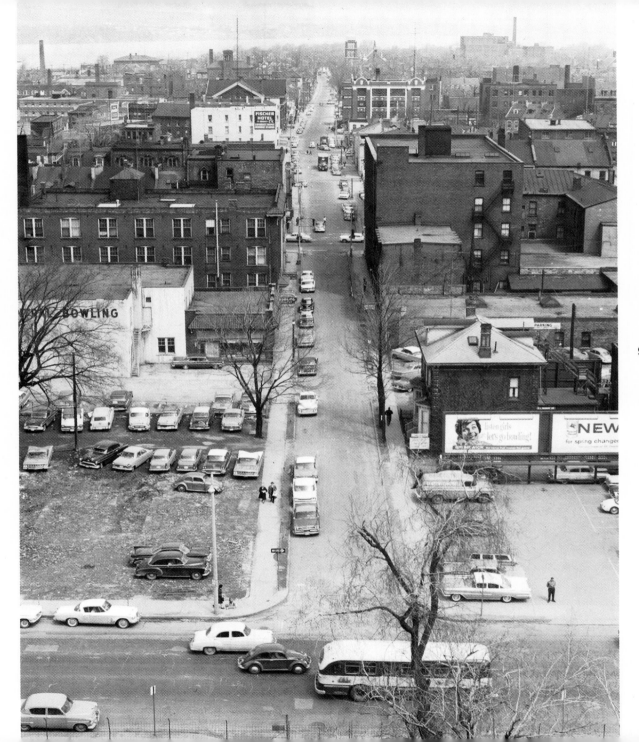

9

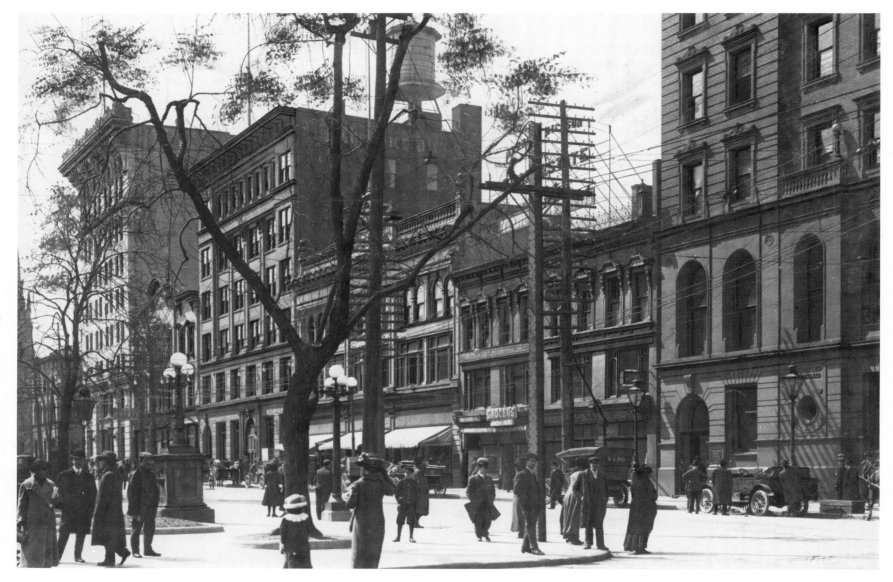

Changing times. Captured in a moment of time, the photographer snapped this vivid portrait of James Street South on a chilly day in 1913, years before the Pigott Building would rise over its neighbors and 10 years before the Bank of Hamilton building, at right, would merge with the Bank of Commerce. That building was later demolished, with an ultra-modern office complex now on the site. That's the old Spectator building in the centre of the photograph with the water tower on the roof.

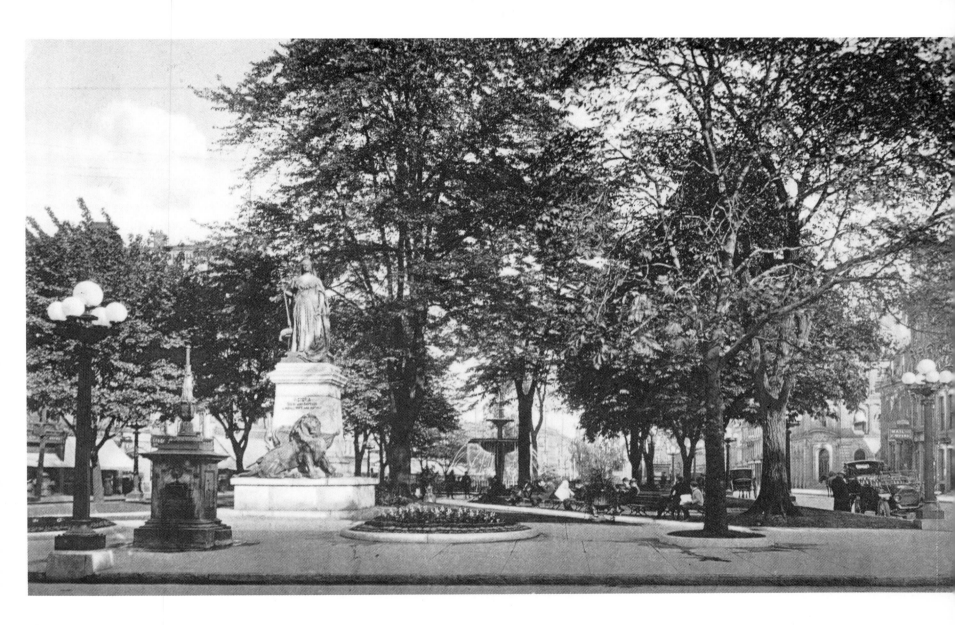

Quiet retreat. The automobile was newly on the scene when the illustration for this postcard was taken in the early part of the 20th century, and as a result, it made for a quiet retreat in the midst of an otherwise bustling city. The horse and buggy was still a viable form of transport as can be seen off to the right, while in the cen-tre of the park, the Gore Park Fountain - the original fountain on the site - provides a focal point for the park. The statue of Queen Victoria, standing at the west end of the park, was unveiled in 1908 after a public subscription for funds and was the first such statue to honor the long-reigning monarch who died in 1901.

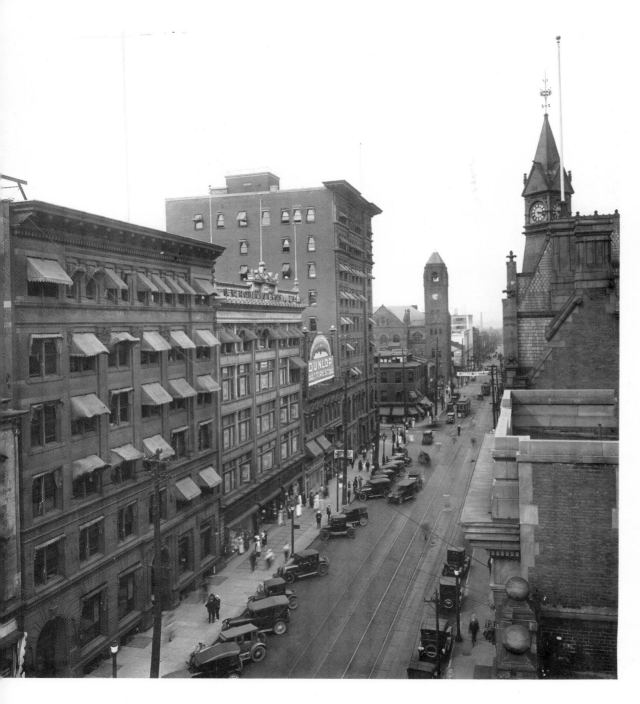

James to the north. It was a different era in many ways when the photographer climbed to the top of the Landed Banking and Loan building to take the photograph, left, of James Street looking north in 1923. The building to the immediate left is the Commerce Centre, built in 1856, and demolished in 1928 to make way for the Pigott Building now standing on the site. Further down the street is the eight-storey Bank of Hamilton, looking out over Gore Park, and across King Street, the old City Hall and the Arcade Building, later to be converted to an Eaton's store. There was two-way traffic on James Street in those days, with a double set of streetcar tracks on the busy thoroughfare.

...and James to the south. Photographed at about the same time, but from the city hall tower, the scene in the picture to the right shows James Street looking towards the mountain off in the distance. Once again the Bank of Hamilton dominates the scene, while next to it along King Street is the Hamilton Herald building. The building near the centre of the photograph with the magnificent clock is Canada Life Assurance. The building was severely damaged by a fire in 1929 and when it reopened, it was known as the Birks Building, until it was demolished in 1972 for a 15-storey office tower.

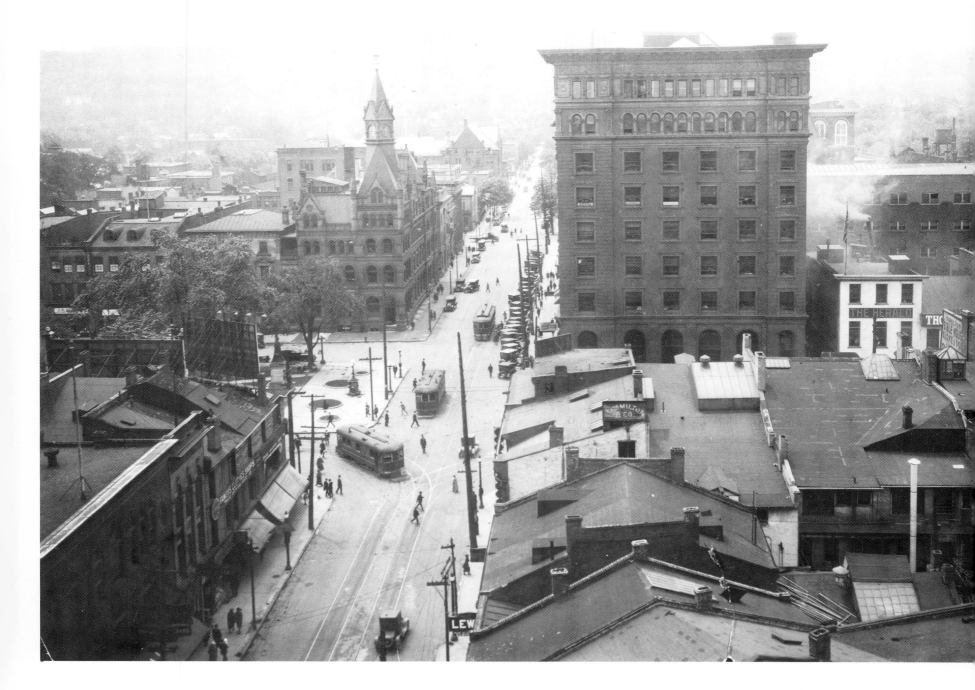

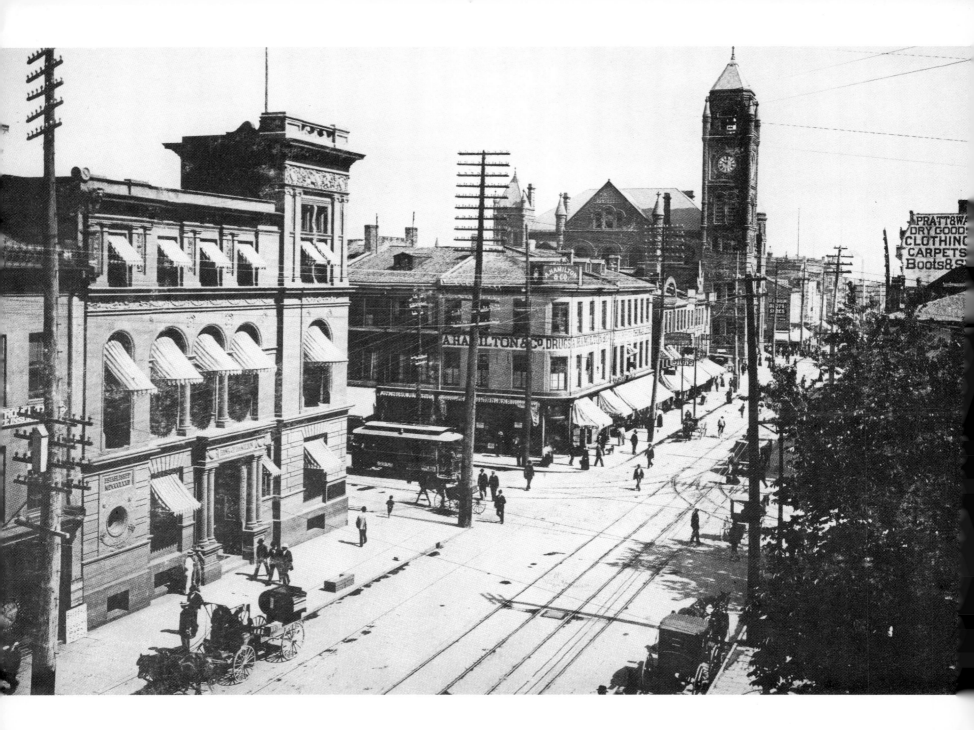

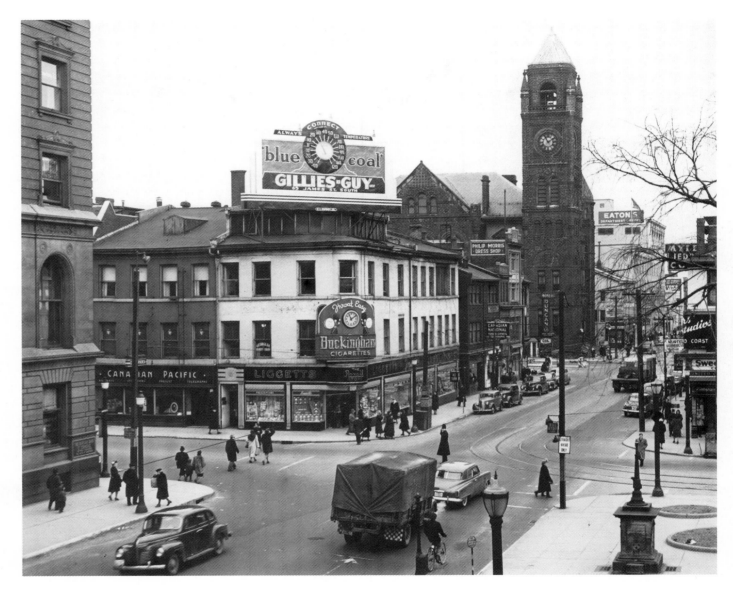

At the core. The intersection of King and James streets has always been at the heart of Hamilton's downtown, the crossroads of the developing city. Here, in these two photographs taken more than 50 years apart, the photographers have captured James Street North from much the same angle as it crosses King Street and heads past the old city hall. The photograph on the opposite page was taken in 1895 while the scene above is from February, 1950.

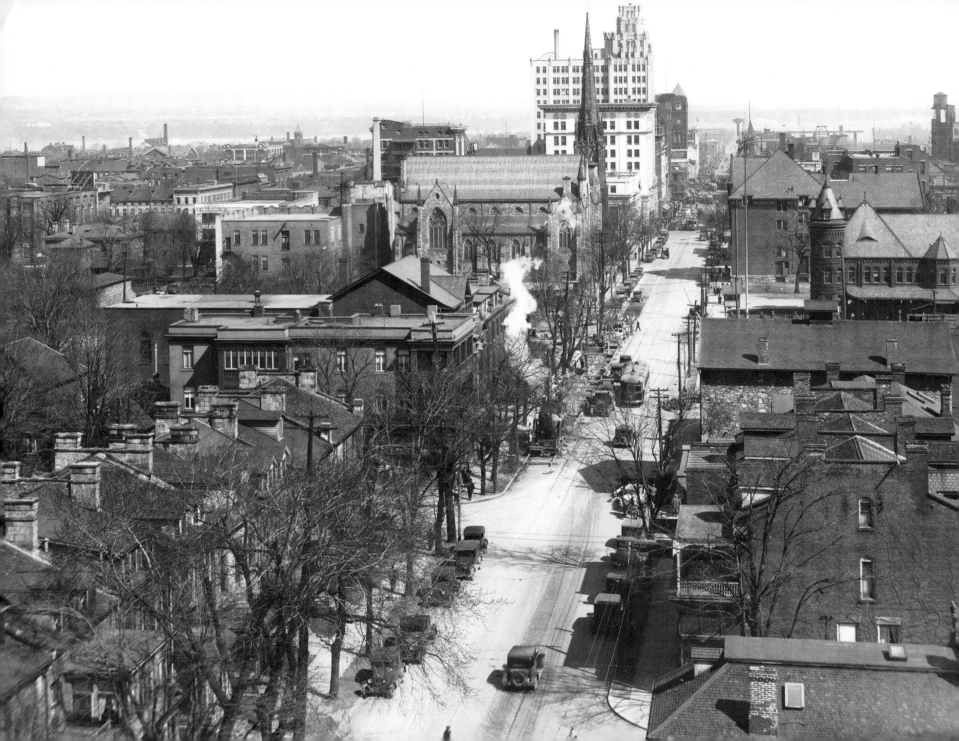

From above and below. These two photographs of James Street South were taken about 1930, showing the thoroughfare from two distinct vantage points. In the photograph at left, there is still a level crossing at the TH&B tracks and the ornate train station is still in use. The vantage point offers a far ranging view over the area west of James Street and out to Burlington Bay. Some of the same buildings can be seen in the photograph to the right with St. Paul's Presbyterian Church, the Pigott Building and off in the distance, the old city hall dominating the landscape.

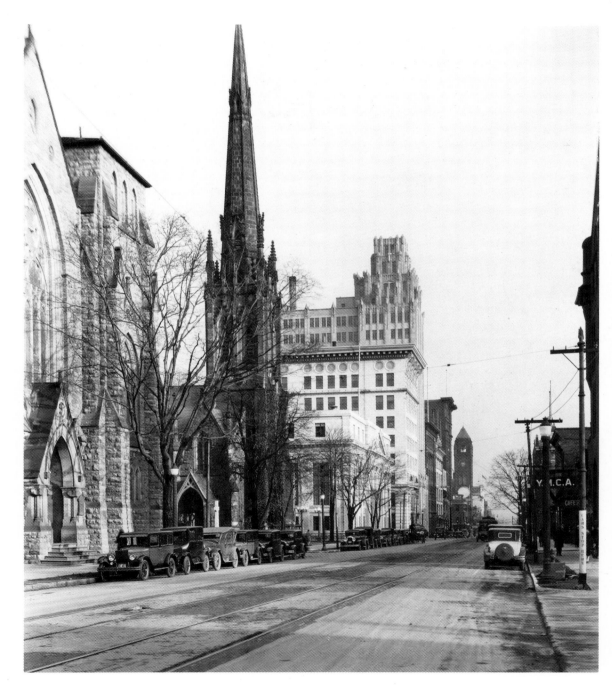

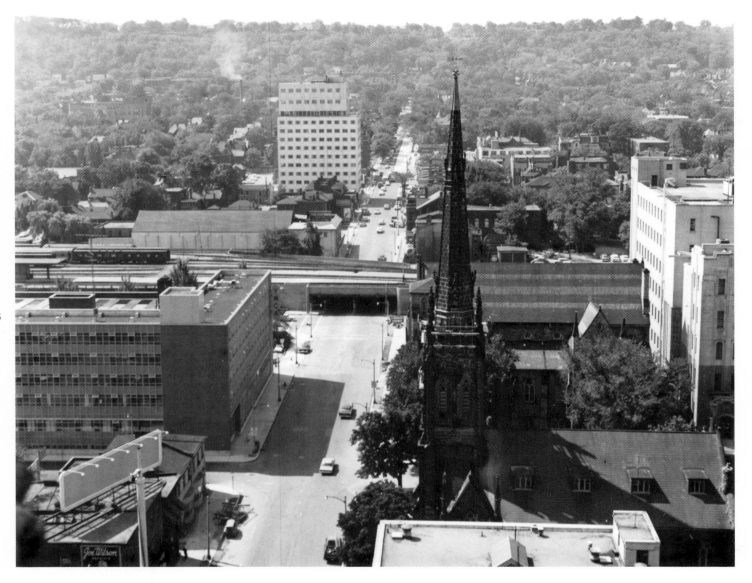

Spire high. The top of the spire of St. Paul's Presbyterian Church on James Street is at the same height as the camera lens in this photograph taken in the early 1960s from the Pigott Building further north on the street. Looking south towards the escarpment, the photograph shows the old Alexandra dance hall and roller skating rink, on the east side of the street just beyond the railway underpass. Off in the distance are many of the buildings of historic Hamilton and two of the access routes up the escarpment.

It just grew. When the Bank of Hamilton was built in 1892, it was a small, but impressive building at the southwest corner of King and James streets. As the bank grew, the decision was made to add another five floors to the structure and for many years this building towered over Gore Park. The Bank of Hamilton merged with the Bank of Commerce in 1923, and when the building pictured here was demolished in the 1980s, a new office building was erected on the site, with the CIBC tower now rising high over the downtown core.

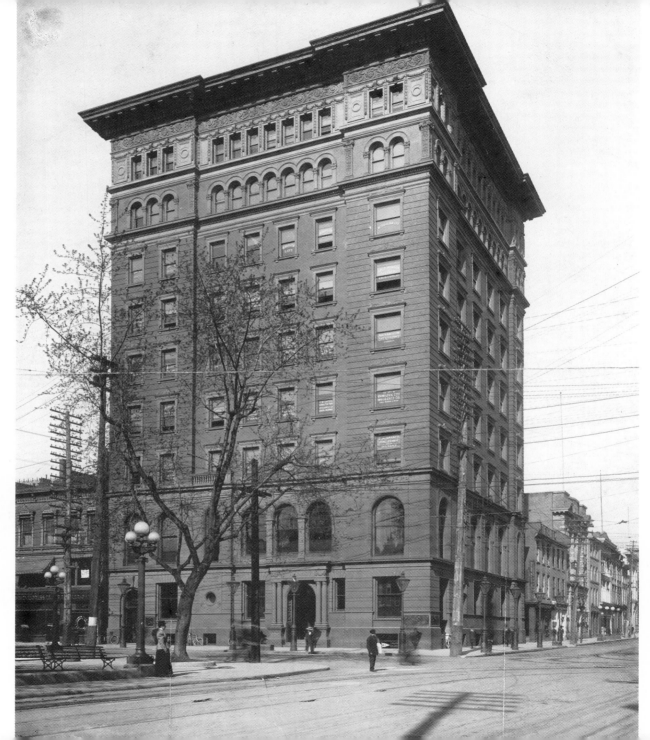

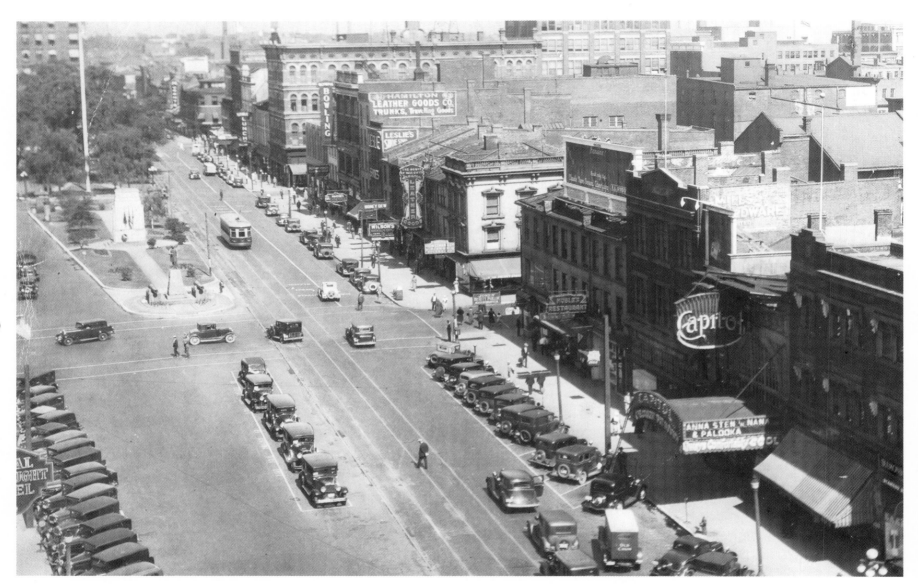

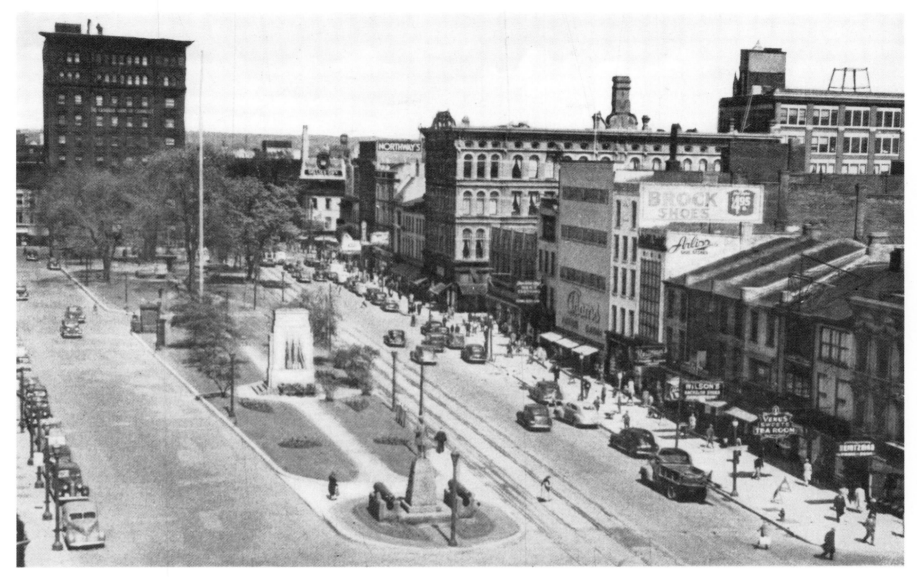

Two views, years apart. The photographs on the opposite page and above were both taken from high atop the Royal Connaught, albeit from different parts of the King Street building, thus providing different views of the street below. The photograph on the opposite page was taken about 1932 and shows not only angle parking along the street, but cars parked in the middle of the street at the east end of Gore Park. The CIBC building towers over the downtown area in the photograph above but by now, parallel parking has been introduced on the busy downtown street.

Pioneer days. There are earlier photographs of downtown Hamilton - not that much earlier - but the above photograph taken in 1862 from one of the buildings on James Street captures the heart of the community just 16 years after it became a city. The Gore Park Fountain, dedicated just two years previous, can be seen in the centre of the photograph while many horse and buggies can be seen along King Street. Note all the buildings with wooden awnings over the sidewalks.

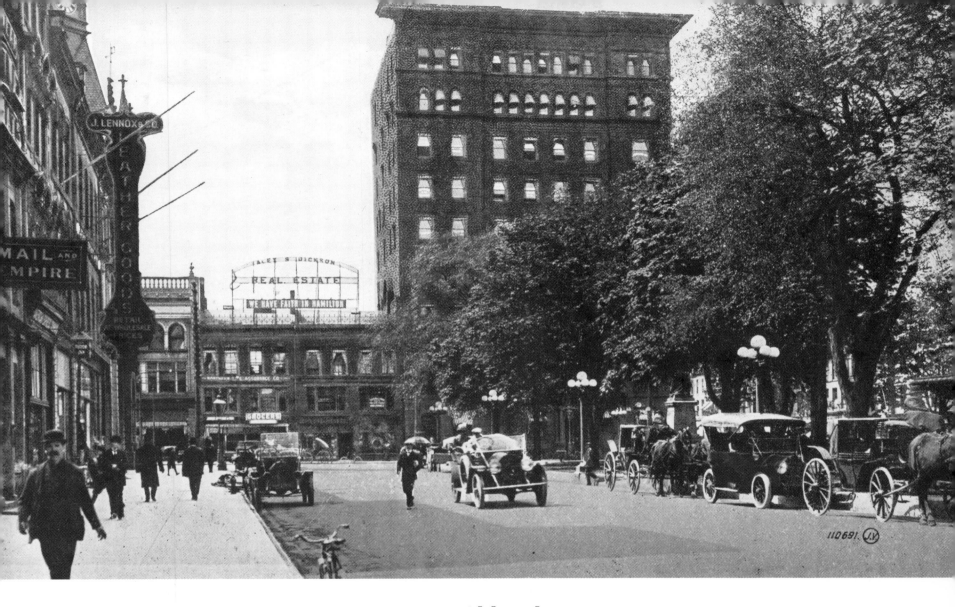

Olden days scene. The horse and buggy was just as much a part of the scenery as the automobile when this photograph was taken of the south branch of King Street for this postcard mailed in 1915. The old Bank of Hamilton building at the corner of James and King streets rises high over Gore Park while the Canada Life clock can be seen at top left.

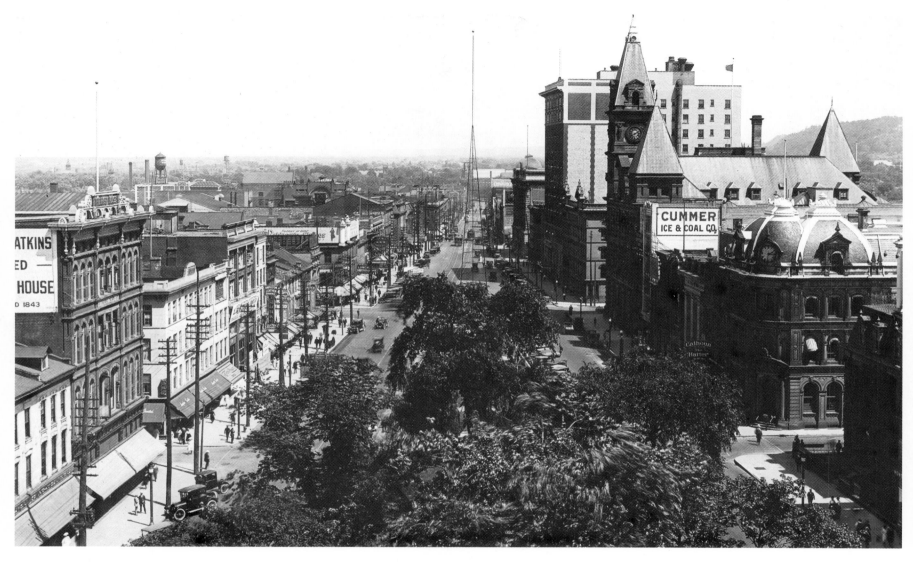

High above Gore.

There is about 47 years between these two photographs of downtown Hamilton, showing many of the same buildings, but also the development of the core area. The photograph above, taken about 1910, shows a long row of street awnings on the sunny side of the street, in contrast to the 1957 photograph, opposite page, where only the Woolworth store had this throwback to earlier times. As the eye travels down King Street, many of those buildings still standing from the 1910 photograph have undergone major changes, but gone from the scene is the magnificent old post office with its clock tower, replaced in 1936 by the present building on the site. The original Gore Park Fountain is visible in the photograph to the right, but hidden by the trees above.

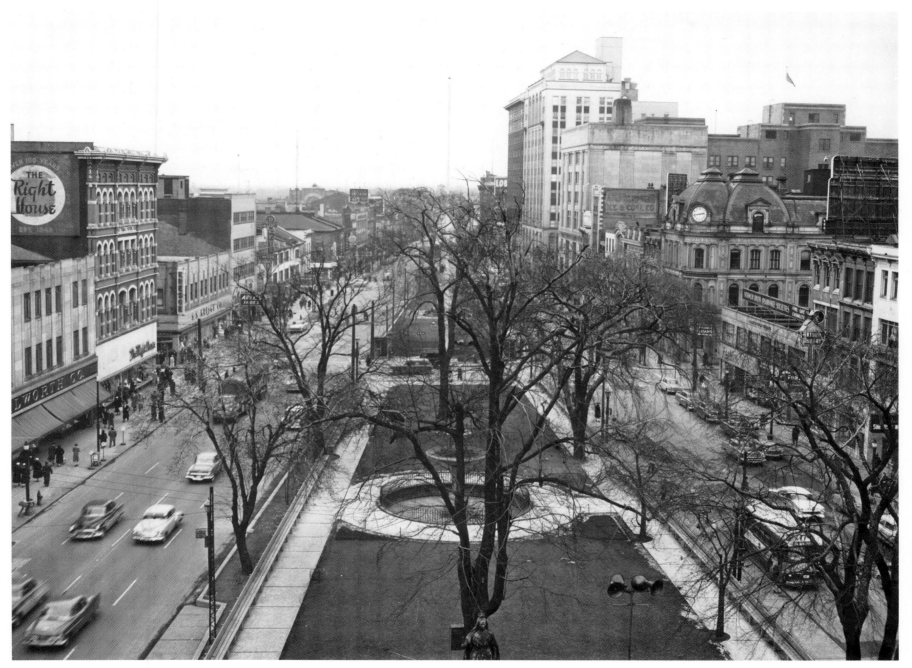

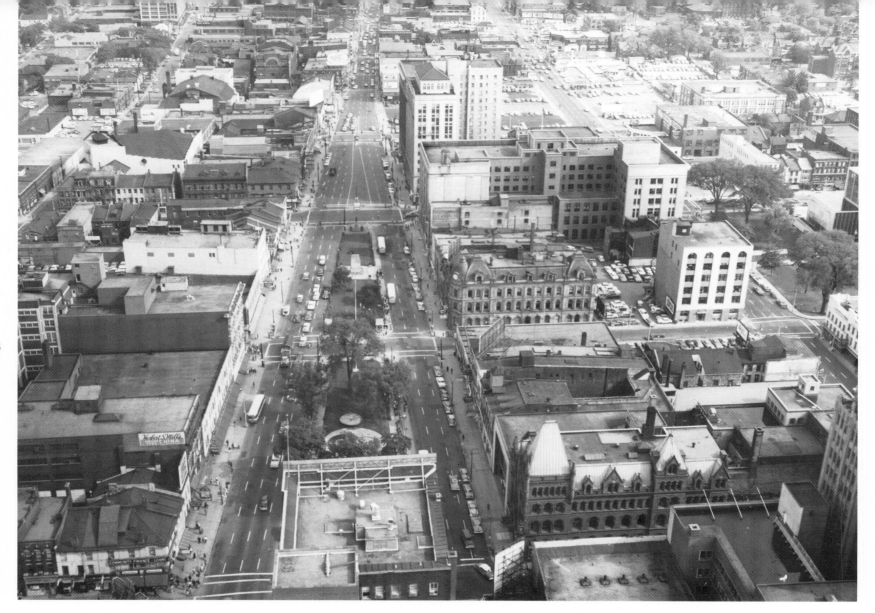

From the west. This low-level aerial view offers a different perspective of Hamilton's downtown core in about 1960, long before many of today's high-rise office buildings were built. Taken from high over the old CIBC building on James Street, the photograph looks east on King Street and shows some of the grand, old buildings with links to another century. Off in the distance, along Main Street, are huge open areas, used back then as parking lots.

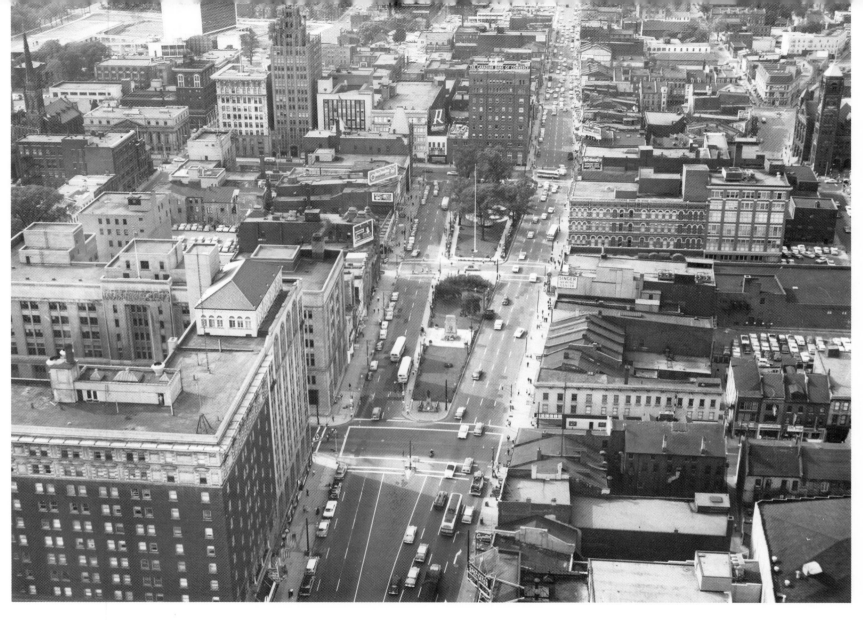

And from the east. As the plane circled around downtown Hamilton, the photographer was able to get the opposite view, showing King Street to the west. The new city hall building can be seen to the top left, while off to the right is the old city hall, waiting for the demolition crew. The Royal Connaught Hotel, bottom left, towers over the old post office building, while the two-block long section of Gore Park offers a bit of greenery to the downtown core.

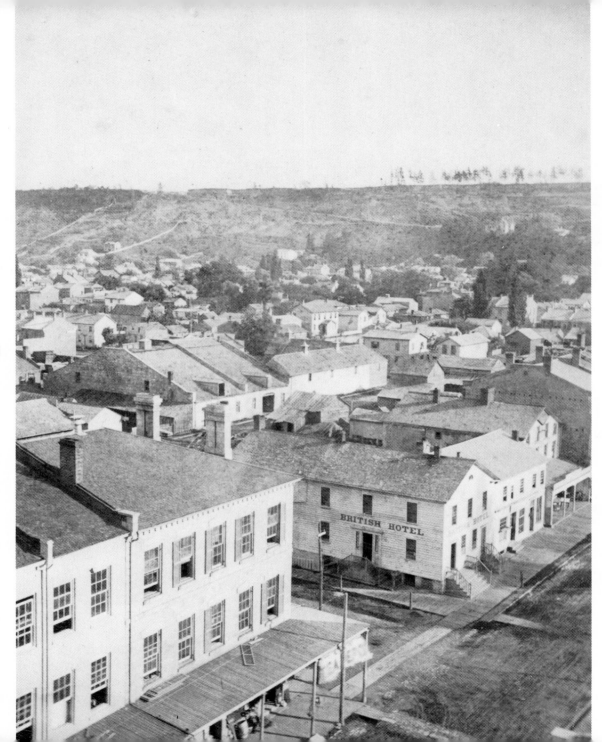

Changing scenery. The same photograph today would reveal a densely populated area, interspersed with several tall buildings, and lots of towering trees, but when taken back in 1875, this photograph looking south-east from Main and John streets toward the Jolly Cut painted a much different picture. The photograph was taken by James Esson, a well-known photographer of that era, who documented such scenes throughout many parts of Ontario.

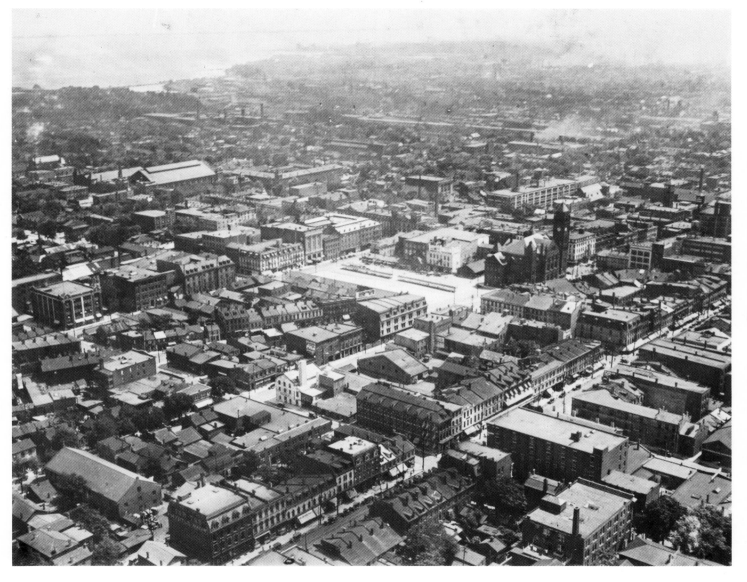

Old time flyer. A great many aerial photographs have been taken of the city of Hamilton over the years, but this was one of the earliest such pictures, dating back to 1919. Taken looking to the north-east, over the downtown area and off to the bay, most of the buildings in the foreground including the massive city hall structure in the centre of the photograph have been demolished over the years as part of the redevelopment of the city.

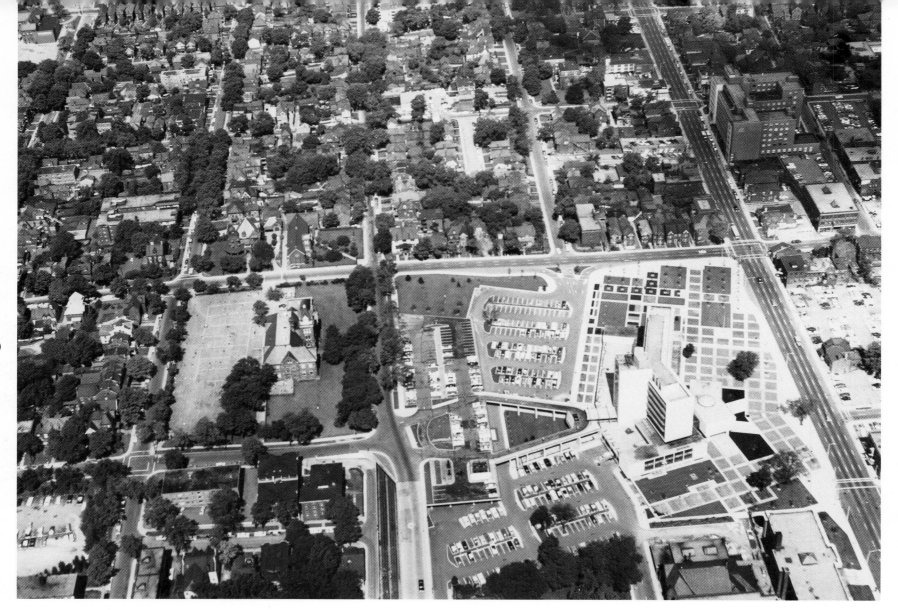

From high above. Hamilton's city hall is the focal point for these two aerial photographs taken in 1964, showing the area to the west of the municipal building above, and to the north on the opposite page. Central School can be seen behind the city hall building, above, with the railway tracks disappear- ing into the Hunter Street tunnel to emerge much further to the west. On the opposite page, much of that area in front of city hall has been razed since this photograph was taken, replaced with Hamilton Place, Jackson Square, Copps Coliseum and vari- ous high-rise office towers.

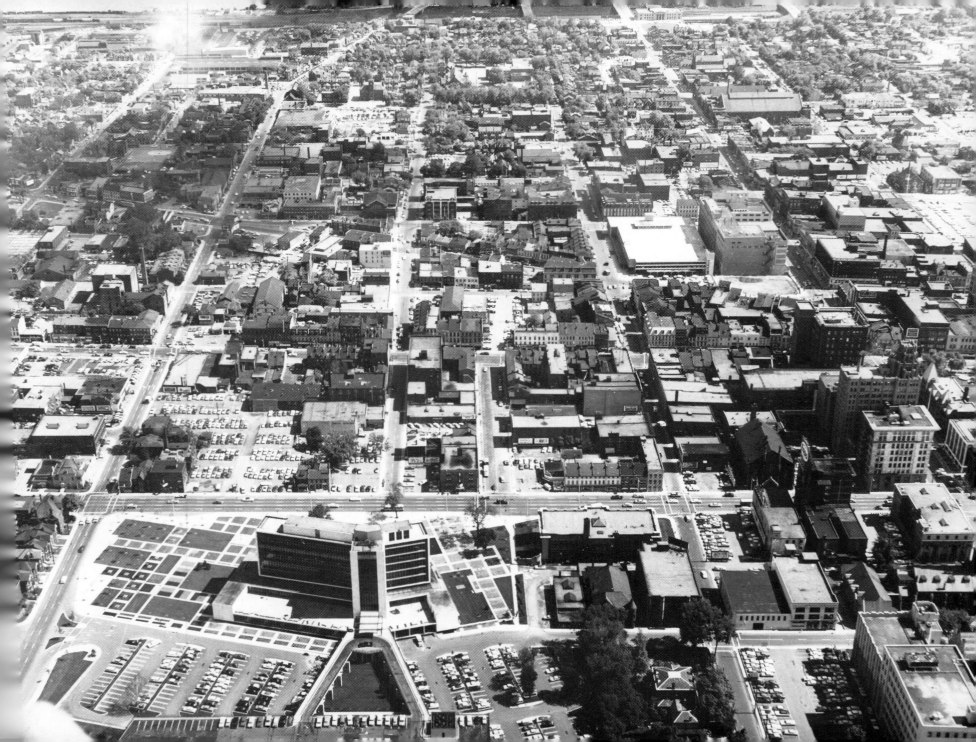

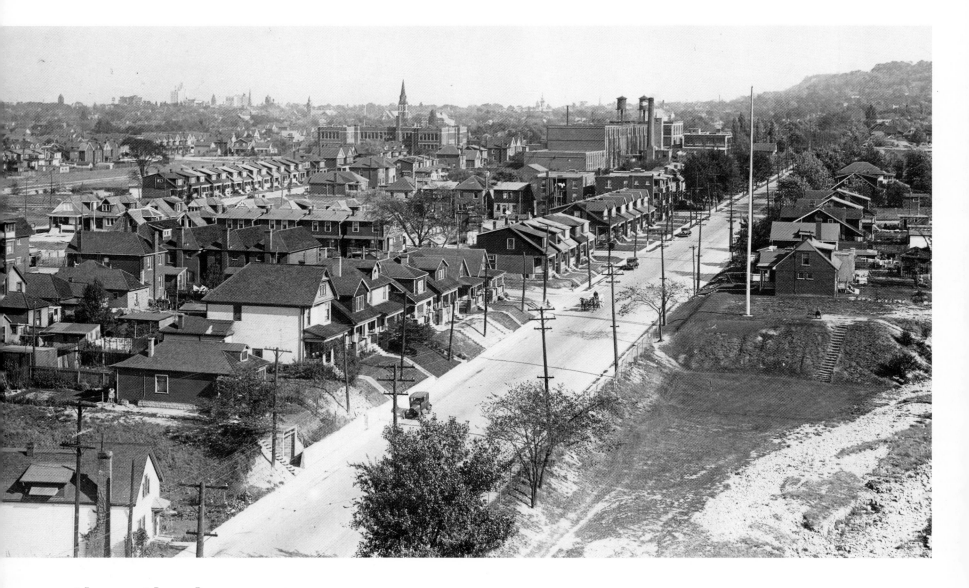

Along Aberdeen. There are few early photographs of Aberdeen Avenue, much less ones taken from the air, but this aerial shot shows not only the Aberdeen streetscape, but many of the homes in the neighborhood. The low level photograph, taken in about 1930 while flying over Chedoke Golf Course, shows very little traffic on the street, just three cars parked along the broad street and a horse and wagon. Many of the houses shown here still make up this neighborhood to the west of Dundurn Street.

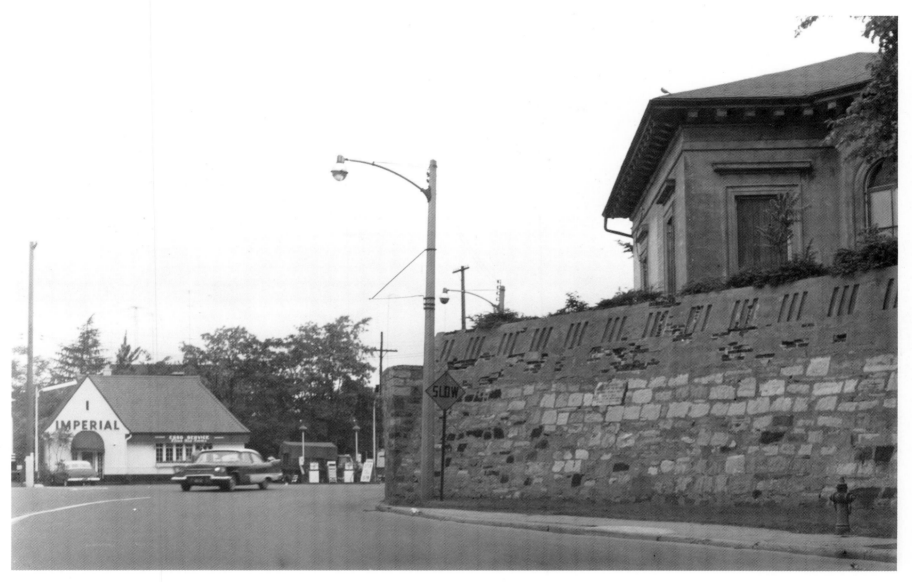

Shifting history. It was the subject of much debate as the corner of York and Dundurn was the scene of many serious car accidents. The blind corner was the result of the road nudging up against the earthworks around Battery Lodge, a piece of Hamilton's history which dates back to the 1830s. This 1961 pho-tograph shows the scene as one approaches the intersection from the east with Dundurn Castle hidden off to the right. Years later, with the redevelopment of York Street the historic structure would be moved back 150 feet, eliminating the blind corner and making it safer for the increased traffic flow of today.

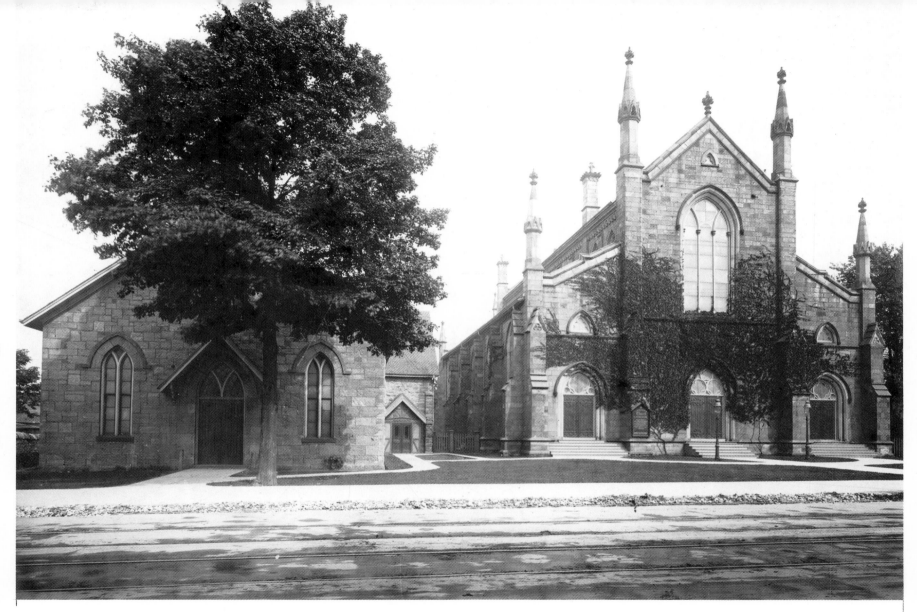

Christ's Church. It had its beginnings in 1835, 11 years before Hamilton became a city, and through several building programs over the years, Christ's Church has been part of the landscape on James Street North. The present church building dates back to 1876, to a time when it became the mother church of the new Anglican diocese of Niagara, and subsequently became Christ's Church Cathedral. There is no date on this photograph of the cathedral, but it dates back to the early 1900s.

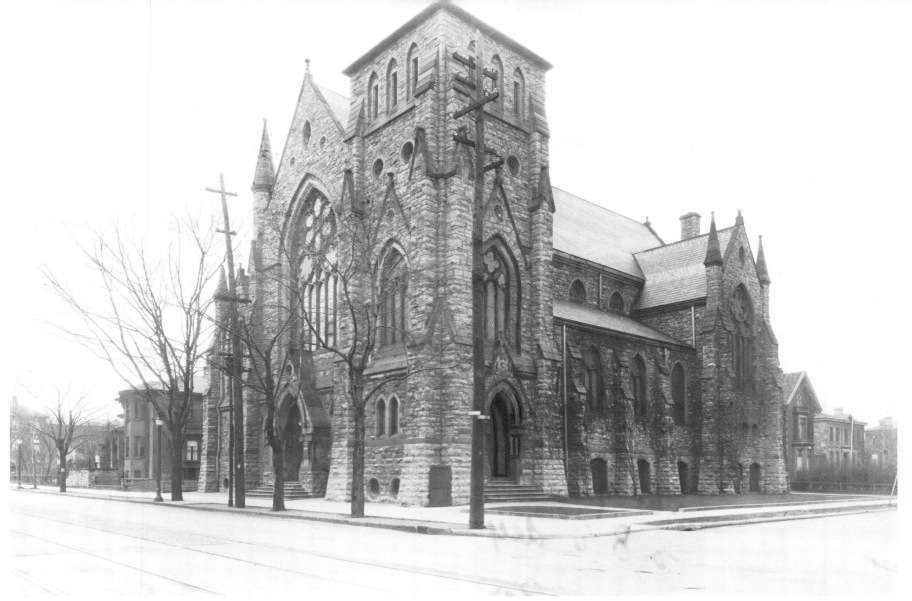

James Street Baptist. There were several magnificent church buildings erected in the downtown area of Hamilton in the 1800s, many of them built of cut stone, such as this impressive structure at the southwest corner of James and Jackson streets.

James Street Baptist Church, shown here in this 1944 photograph, had its beginnings in 1843, and as the church grew, property for the present building was purchased in 1878, and four years later, the new church was dedicated.

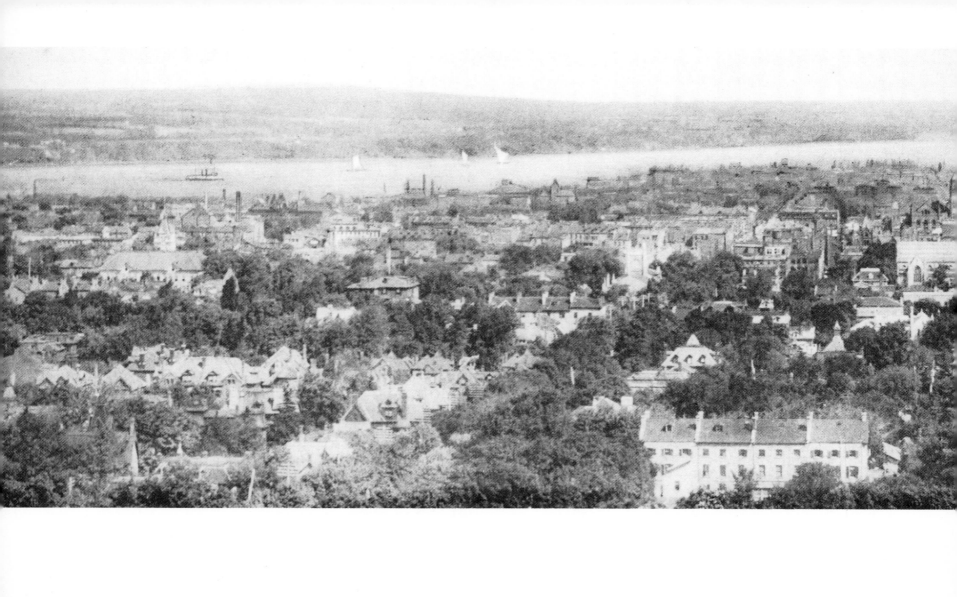

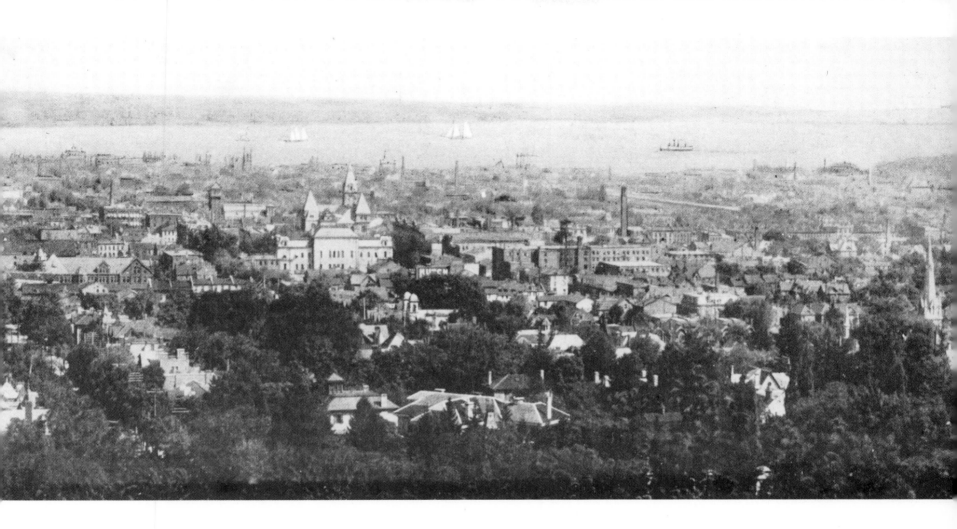

Early view. An old fold-over postcard provides a fascinating look at what the city of Hamilton looked like from the edge of the escarpment in the early 1900s. That's James Street running through the centre of the illustration, with the spire of St. Paul's Church and the old city hall building clearly visible part way down the street. The towers of other churches throughout the city can be seen in this panoramic view, while off to the left is Central School.

38

Lookout point. The edge of the escarpment has been a popular spot for photographers seeking a different view of the city, and those photographs taken high over the city have helped plot the tremendous growth over the years. This photograph, taken in 1958, shows the downtown core and the area stretch-ing south to the escarpment long before much of the high-rise construction changed the city's landscape. The Pigott Building, to the left, towers high above other buildings while to the right can be seen the old post office building and next to it the Royal Connaught Hotel.

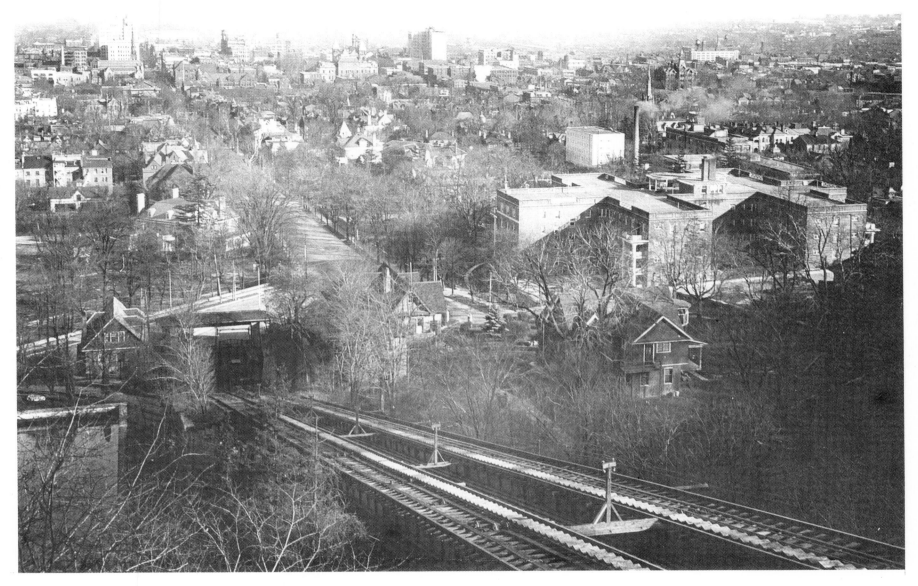

Incline railway. The tracks are long gone, a victim of progress, or in this case, the automobile, but for many years the James Street Incline was not only a fast way to scale the Mountain, but the ride provided a spectacular view of the city. The incline ceased operations in 1931, but the tracks remained until they were salvaged as part of the war effort. That's James Street running through the centre of the photograph and off in the distance, the Pigott Building soars over the downtown core. St. Joseph's Hospital is that sprawling structure just to the right, offering a much different perspective than the building on the site today.

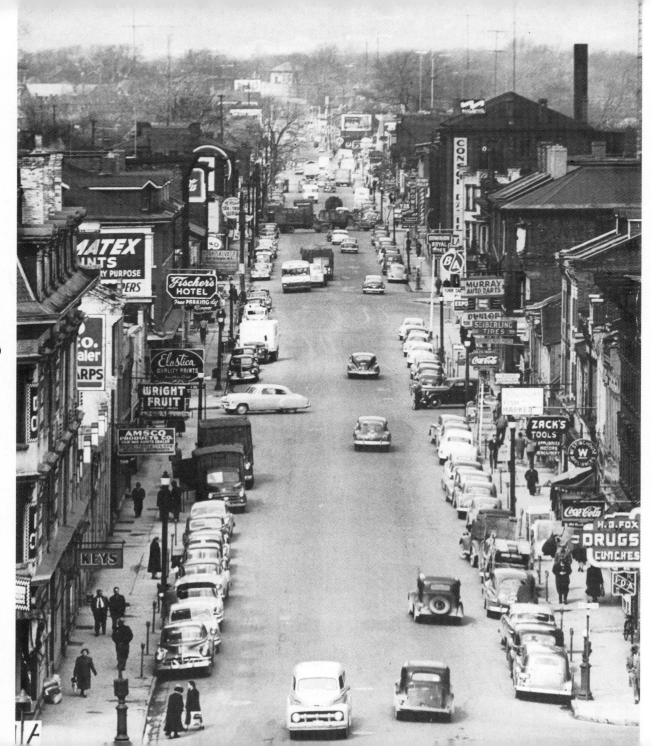

Sign of the times. This is York Street - a traffic-choked ribbon of asphalt rimmed by signs of our times. Here are keys, cars, shoes, ships, cabbages, gipsy kings - and people. That was the cutline on this Spectator photograph taken in 1953, showing a street alive with activity, with an eclectic mix of stores and services. The street was the scene of a major urban renewal program several decades after this photograph was taken, so that today, the street has a much different appearance.

Scene from yesteryear.

The year is 1964, long before re-development changed the land-scape in the downtown core, and long before most of the buildings pictured here were torn down. The street through the centre of the photograph would go right through today's Copps Coliseum and Jackson Square. That's Bay Street at the bottom of the photograph, and to the left is the Salvation Army building, still standing on York Street today. Eaton's is just at the top of the photograph with the large parking garage dominating that area of the downtown core.

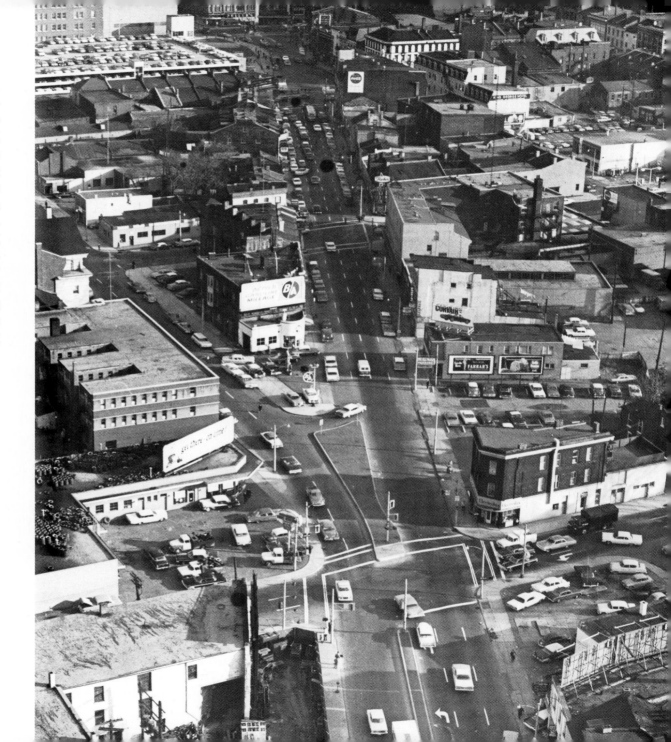

42

Traffic jam. There is nothing unusual about this scene on York Street. In fact, traffic congestion as seen here was the norm in the years before urban renewal resulted in a wider street and fewer retail outlets along this busy thoroughfare. The photograph here was taken in 1965 looking east from Locke Street. All of the buildings along the street are now only a memory, demolished as part of the revitalization program.

A new look. Years later, York Street had a much different appearance as the businesses have been demolished, replaced at that time by lots of green space. The street has been widened to six lanes, with a wide boulevard and extensive street lighting. In this 1976 photograph, Battery Lodge has been moved back from the street, opening up the intersection to provide good visibility for motorists. Today, the area has been redeveloped once again, this time with a number of new buildings lining this entrance to the downtown core.

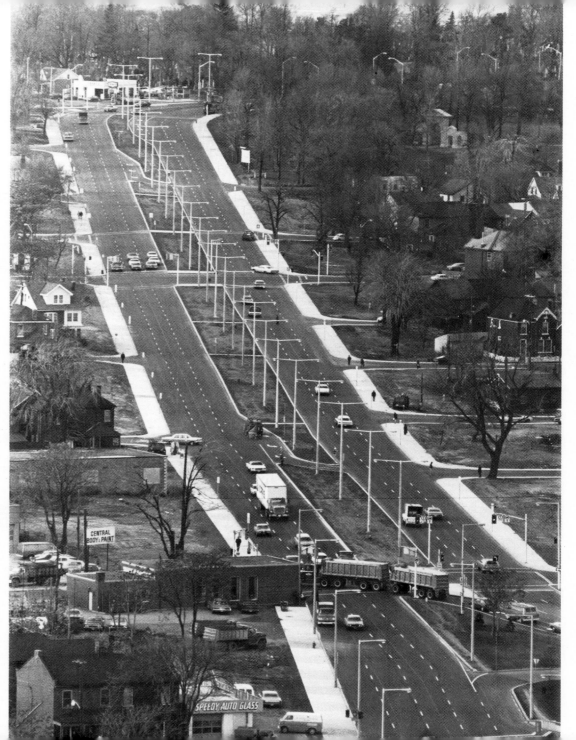

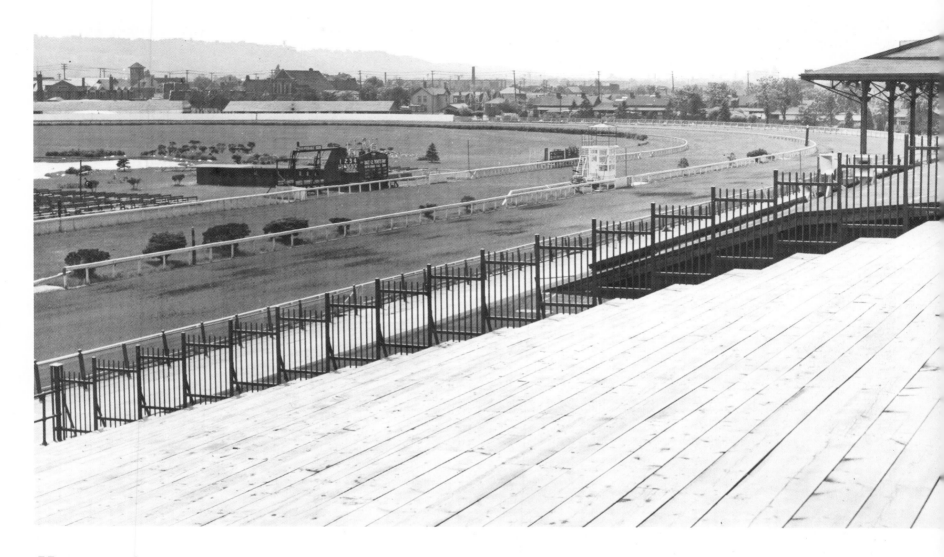

Horse racing. It is a real study in contrasts between these two photographs taken many years apart at the Hamilton Jockey Club track where the Centre Mall is now located. In the photograph at left, it was obviously a grand occasion as everyone appears to be dressed in their holiday finest as they watch with interest as the horses race to the finish line. Years later, the stands are empty and the track is silent as the photographer offers an overview of the covered grandstand and the open bleachers in front of the official's stand. The track, built in 1894 on land obtained from the Gage family, was the scene of many important races over the years until it was sold in 1952, and soon thereafter work started on the huge shopping complex.

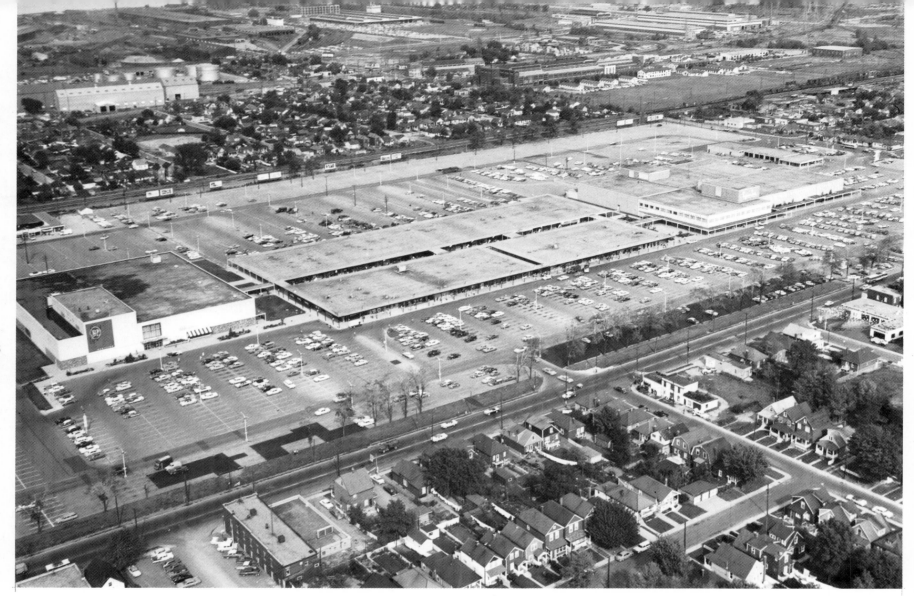

46

From horses to shoppers. The site of the Hamilton Jockey Club for many years, the huge expanse of land at Barton and Kenilworth is now home to the Centre Mall, although when this photograph was taken in 1960, it was known as the Greater Hamilton Shopping Centre. The complex had a much different look at that time as the centre concourse was open to the elements with covered walkways connecting Morgan's department store to the left and Simpson-Sears on the far right to the shopping centre.

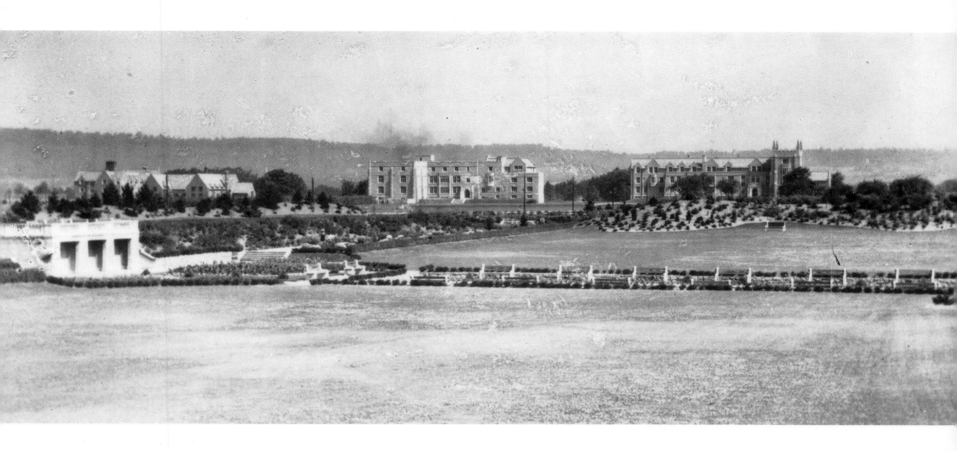

Early campus. It is almost like a maze today, but back when this photograph of the McMaster campus was taken in the early 1930s, there was lots of green space, and few buildings. In this photograph taken for use as a postcard by Cunningham Studios, the photographer looks north-west from Main Street to capture the early buildings as well as the famous Sunken Garden, a beautiful spot which attracted a never-ending stream of tourists. Today, the garden is only a memory, bulldozed under to pave the way for the McMaster University Medical Centre now on the site.

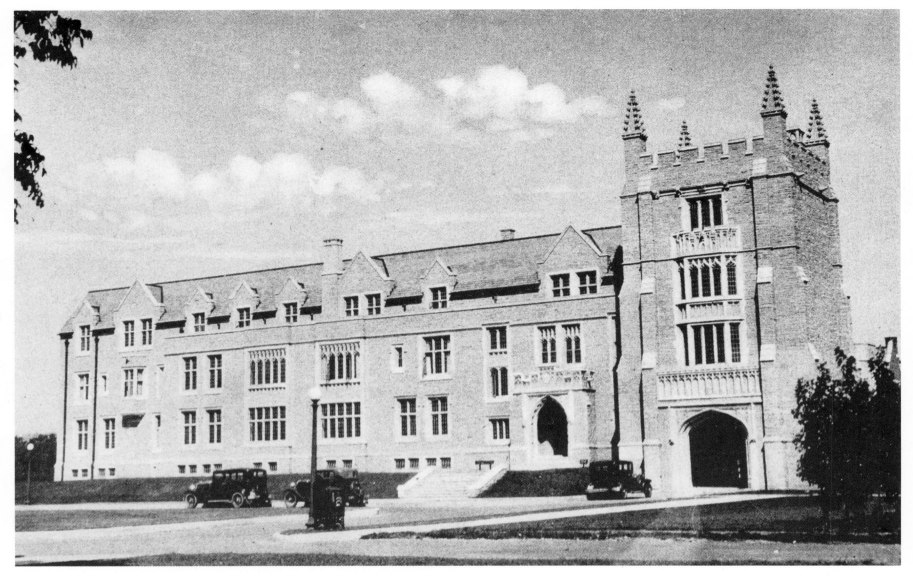

University Hall. It still holds a prominent place on the McMaster campus these days, but when this postcard of University Hall was sent in 1938, it was one of only a few buildings on the sprawling McMaster campus in west Hamilton. It was only eight years previous that the first building was officially opened, and that came after a spirited campaign by citizens of the city to bring the campus to Hamilton after the decision had been made to vacate its Toronto campus.

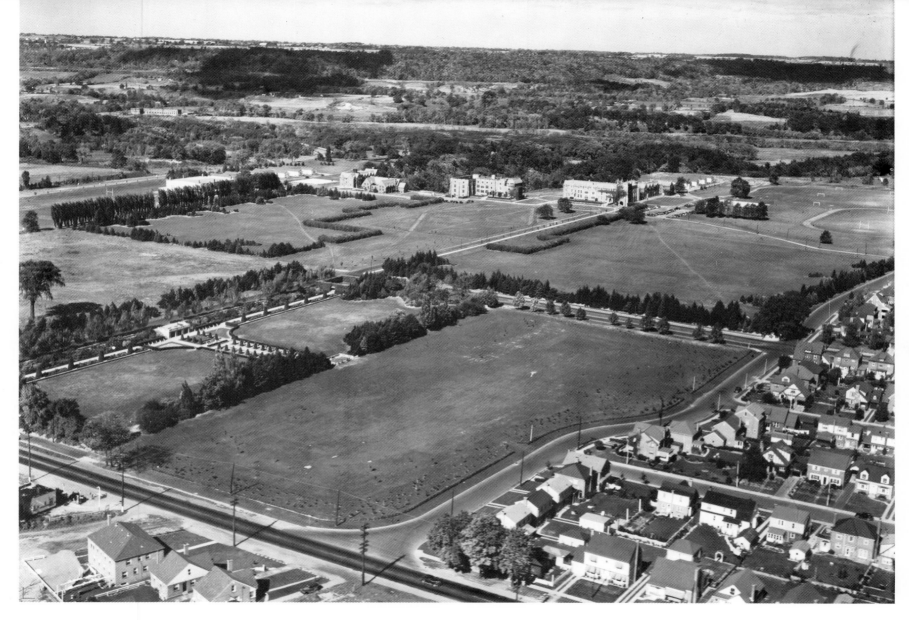

McMaster, 1947. The McMaster University campus has undergone sweeping changes since this aerial photograph was taken in 1947. There were few buildings on the campus at that time, as the photograph was taken long before a building boom took place on the campus. That's Main Street at the bottom of the photograph while King Street goes part way through the campus. The Sunken Garden, a popular tourist spot, can be seen to the left in an area now occupied by the McMaster Medical Centre.

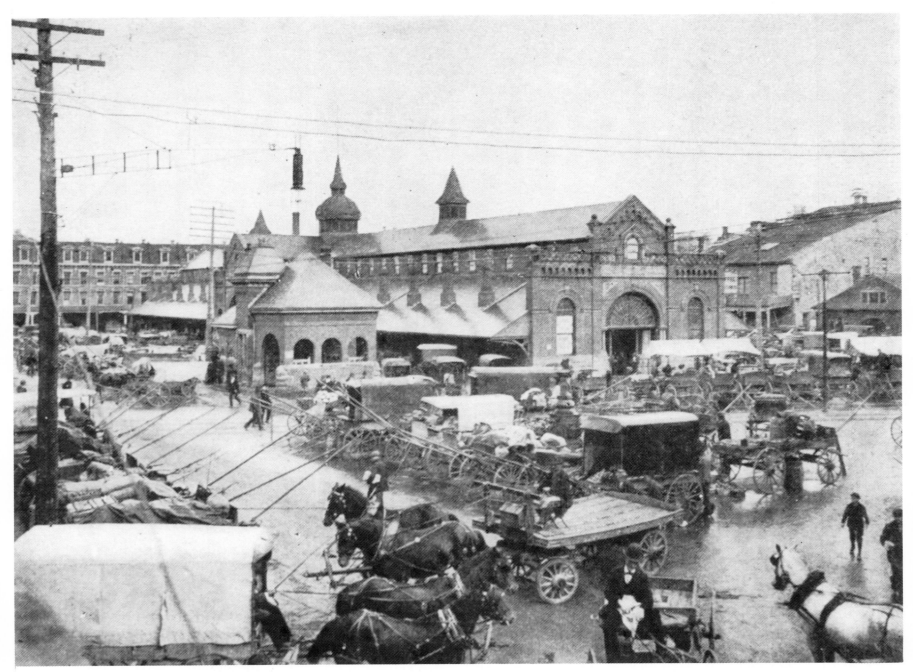

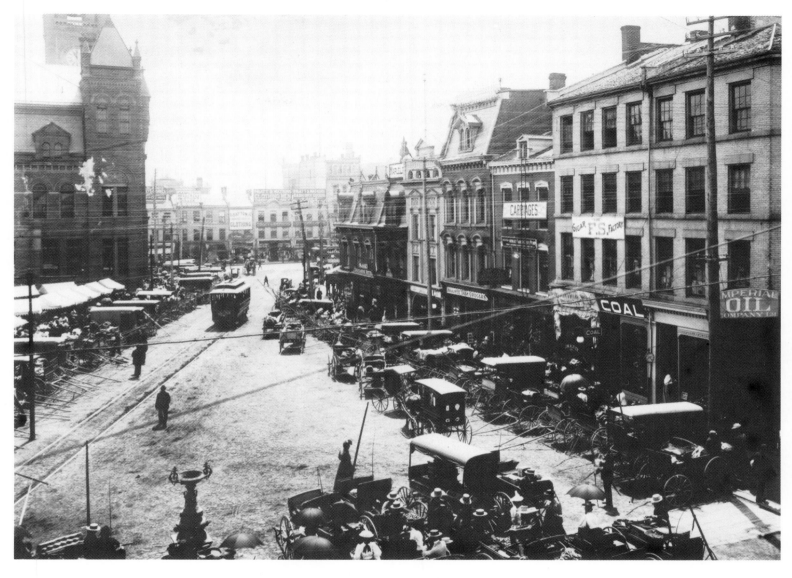

Market day. Hamilton's market has been a fixture in the community since 1837, nine years before Hamilton became a city. It has taken various shapes over those years, but in all that time, it has remained in much the same location, catering to legions of shoppers, seeking goods delivered fresh from the farm. One of the early markets can be seen in the photograph on the opposite page, a photograph taken shortly after the introduction of the street lights, while above, a trolley car heads past the old city hall on a busy market day.

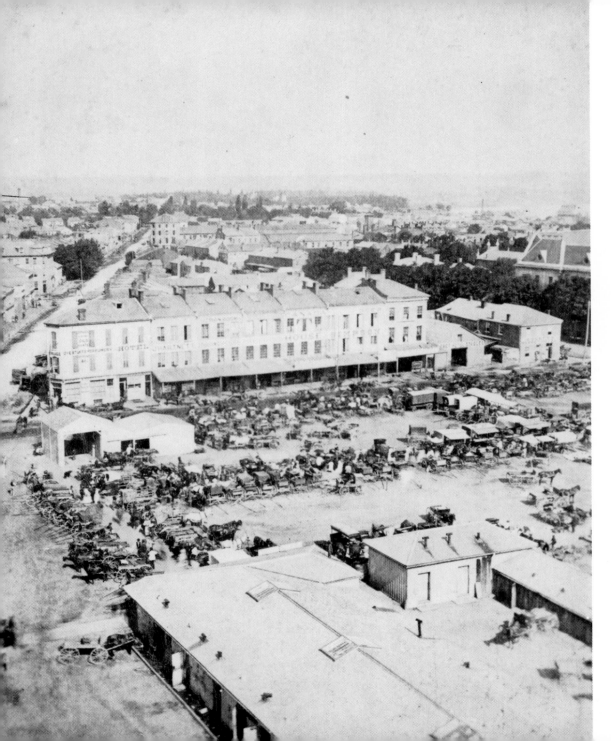

Vantage point. The old city hall tower, then located on James Street North, provided an ideal vantage point to capture Hamilton's famous market square. The photograph was taken in 1875 offering a panoramic view over the market as well as other buildings to the west of the downtown core. The entire area in the foreground is now part of the Jackson Square complex as well as the Hamilton Public Library, Copps Coliseum, and several office towers.

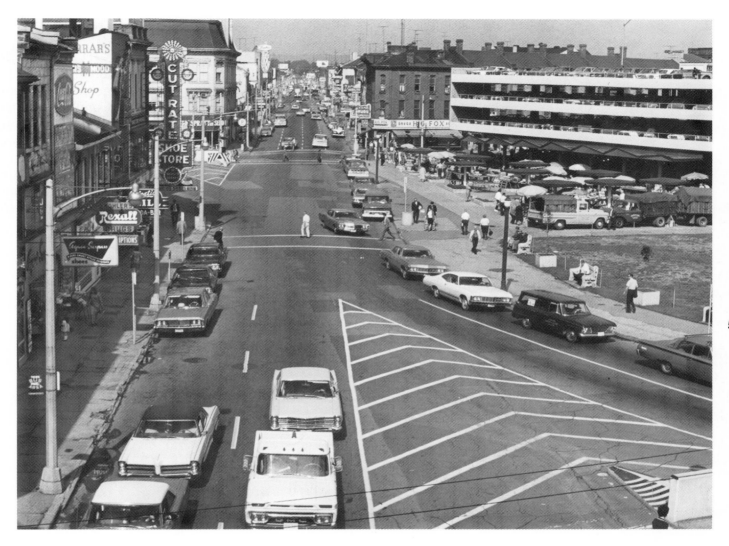

53

Years later. The Hamilton market is still in much the same location as shown on the previous pages, and in fact, that bare patch of grass to the right is where the old city hall building was located until it was demolished in 1961. Taken from one of the upper floors of the old Grafton's building on James Street, the 1968 scene shows a different type of market tucked under the parking garage, while the traffic to the right is heading towards King William Street. That's York Street running off through the centre of the photograph with Spratt Seed at the corner of Market Square and off in the distance is the sign for the old Fisher Hotel. The entire area was later developed as part of Jackson Square and the Eaton's Centre.

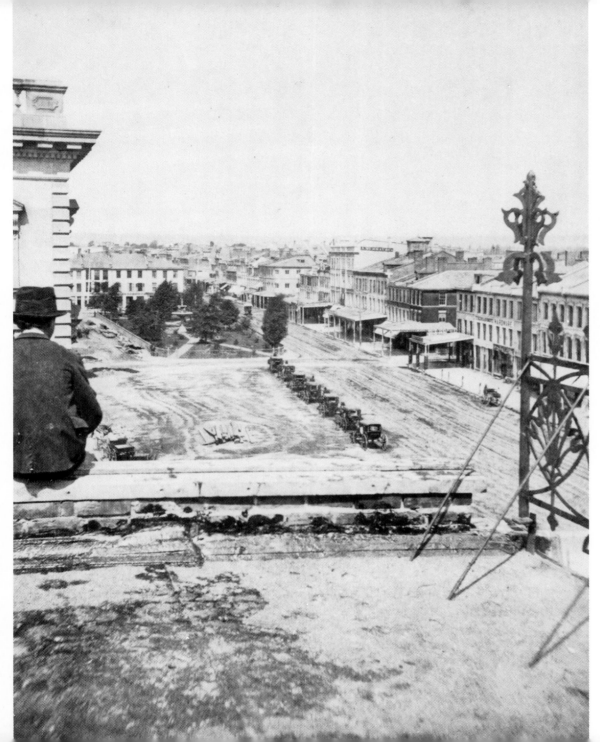

On the edge. Perched at the edge of a tall office building, the man pictured here gets a bird's-eye view of downtown Hamilton, a view that extends over Gore Park, King Street and the early development of the core area of the city. The photograph, taken around 1875, shows the original fountain in Gore Park, and a row of wooden awnings, erected to protect shoppers from the elements.

54

From the tower. The same vantage point is there today, but the scenery west of St. Mary's Roman Catholic Church has changed dramatically since this photograph was taken by James Esson back in 1877. Esson climbed up the tower of the Park Street church to shoot this view, a view that includes Sheaffe Street in the foreground, Bay Street, and off in the distance, the Great Western Railway yards.

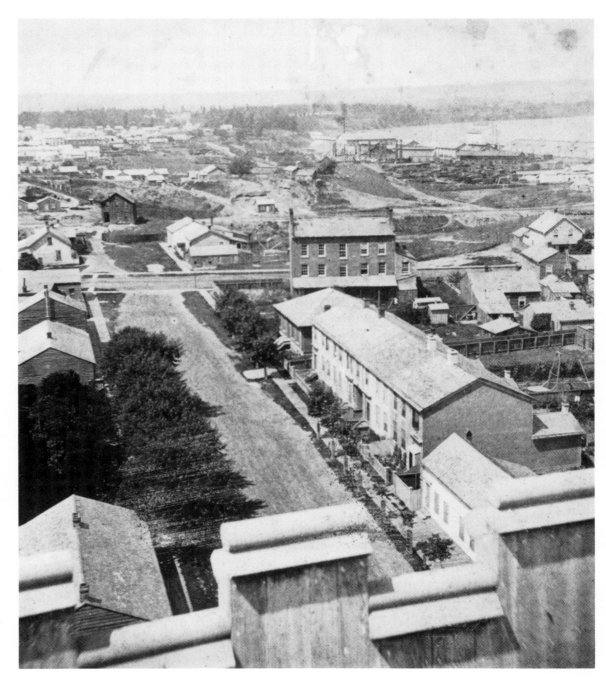

55

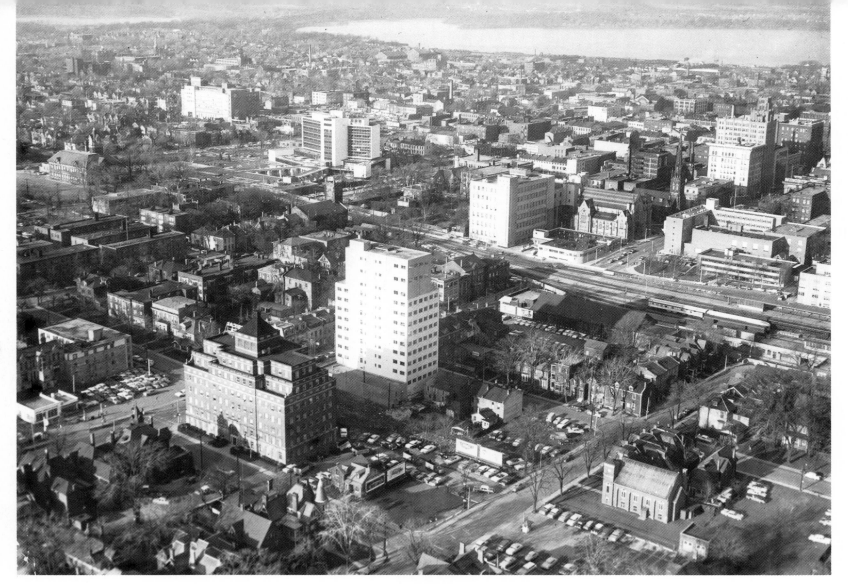

56

Below the Mountain. Flying low over Hamilton Mountain, the photographer has captured on film a vast area of the city west of James Street as it appeared in 1960. The Medical Arts building is in the foreground and behind it, work continues on the new city hall building. That's James Street running from left to right, past stately churches and the Pigott Building.

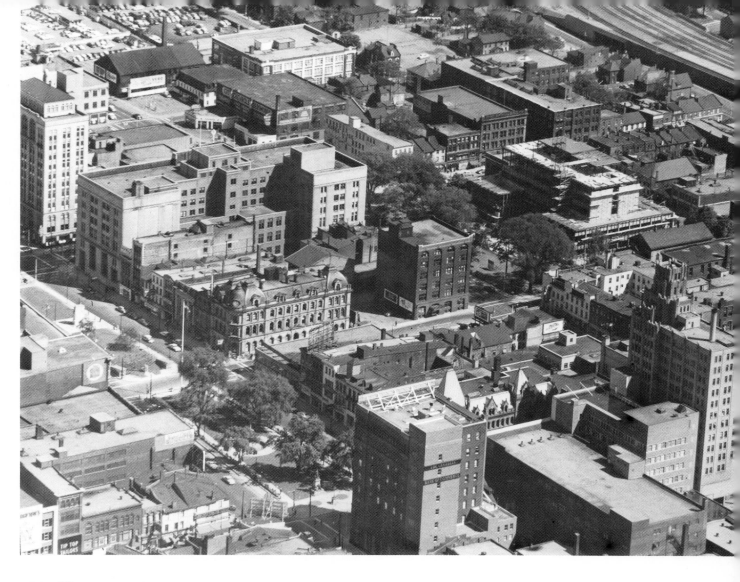

Bird's-eye view. Flying low over what is today's Jackson Square, the photographer has captured an area of downtown Hamilton which has undergone major changes over the years. The Wentworth County building is nearing completion in this 1957 photograph while the area behind the old post office building is years away from being developed as the Century 21 Building. Gore Park can be seen at the bottom of the photograph, with the original fountain almost hidden by the trees.

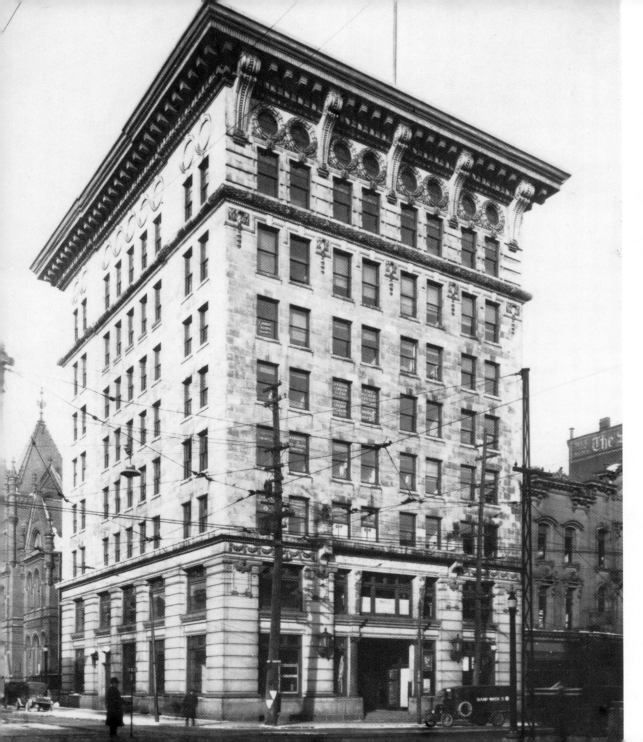

Sun Life. Much like the Bank of Hamilton which anchored the corner of James and King streets in the early 1900s, the Sun Life building anchored the corner of James and Main streets. Both were eight storey buildings, both had ornate features and both were very much a part of Hamilton's business environment. Behind the Sun Life building can be seen the old Hamilton Art Gallery, while just visible on the right is the Hamilton Spectator building, then located on James Street. Note the man in the middle of the street with the traffic pole, indicating stop and go, and the old delivery truck in front of the Sun Life building.

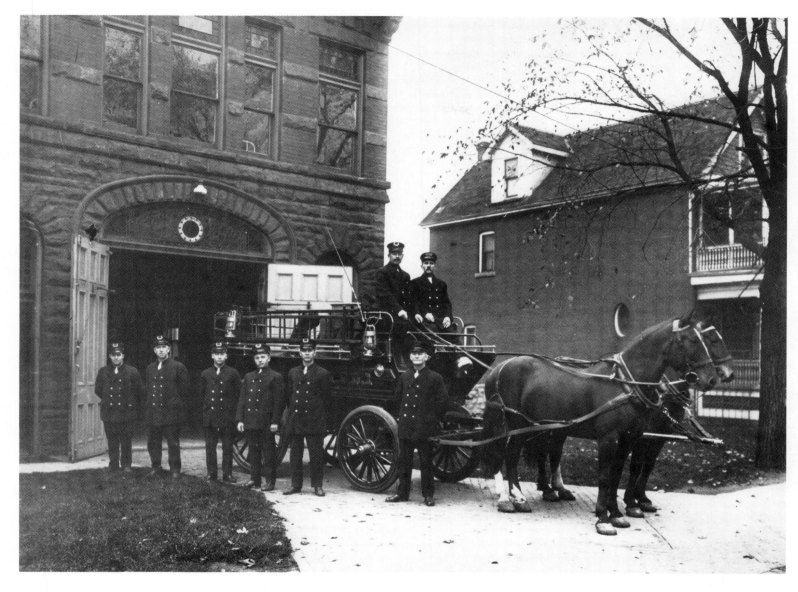

Firefighters. Long before the introduction of the modern fire engine, firefighters in Hamilton raced to the scene of a fire with a wagon pulled by a team of horses such as shown here at the Strathcona Street Fire Station around 1920. The Strathcona fire hall was built in 1897, and was located on Sophia Street before a name change saw the street and the station renamed Strathcona. Trucks replaced the horses in August, 1926, and then, in 1959, the station closed down after a new facility was opened at Ray and George streets.

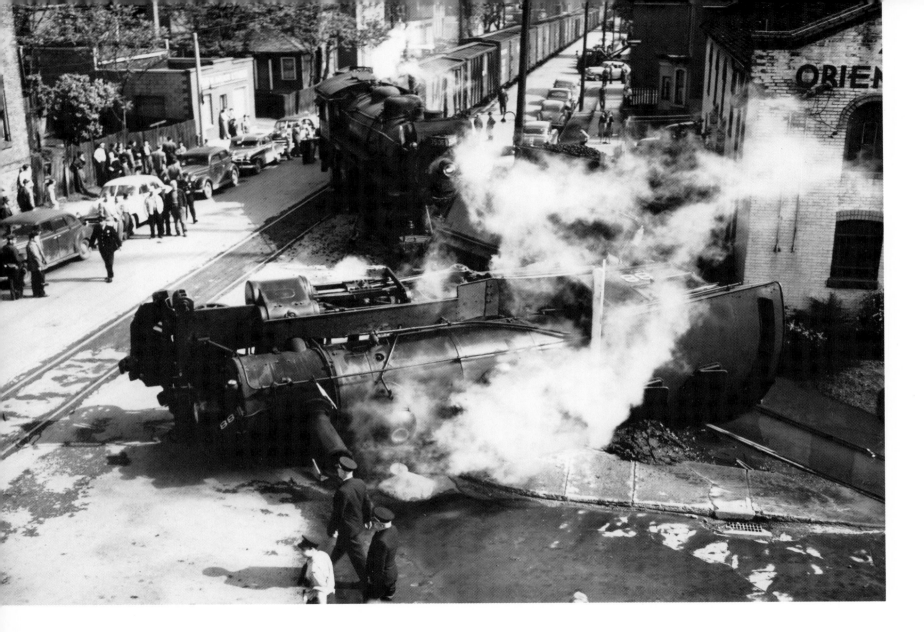

Train wreck. Spectators look on in amazement as they survey the damage from a train wreck at the corner of Ferguson and Rebecca streets in 1953. The lead engine and the tender on this long freight train flipped over as it hit a switch for an industrial siding as it proceeded down along Ferguson towards the Mountain. The overturned engine narrowly missed the Oriental Rug Cleaning Company on the north-east corner of the street, coming to rest just inches from the building which was first opened as a church in 1862.

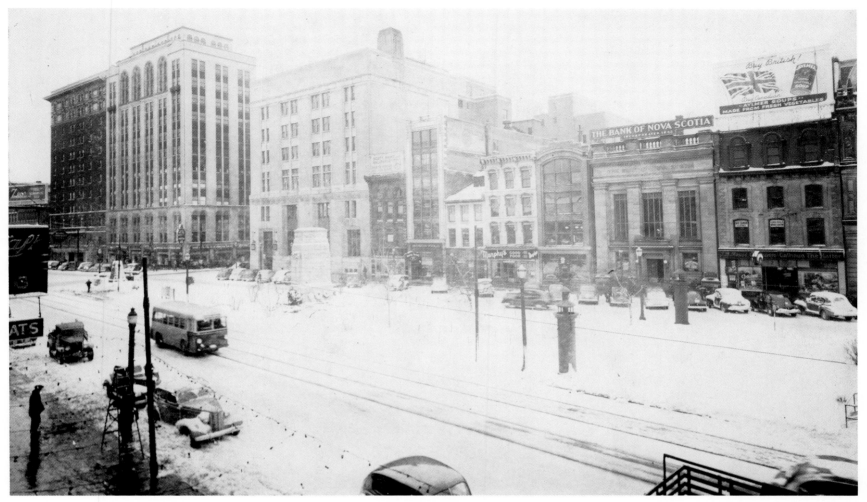

South side. Strings of Christmas lights and a recent snowfall give downtown Hamilton a fresh appearance in this photograph taken from the second floor of the Right House in about 1941. The streetcar tracks are just visible through the snow as little traffic has made its way along King Street, which in those days accommodated two-way traffic. The Royal Connaught and the old post office building still anchor the south side of the street, but much of what can be seen here has undergone vast changes since this photograph was taken.

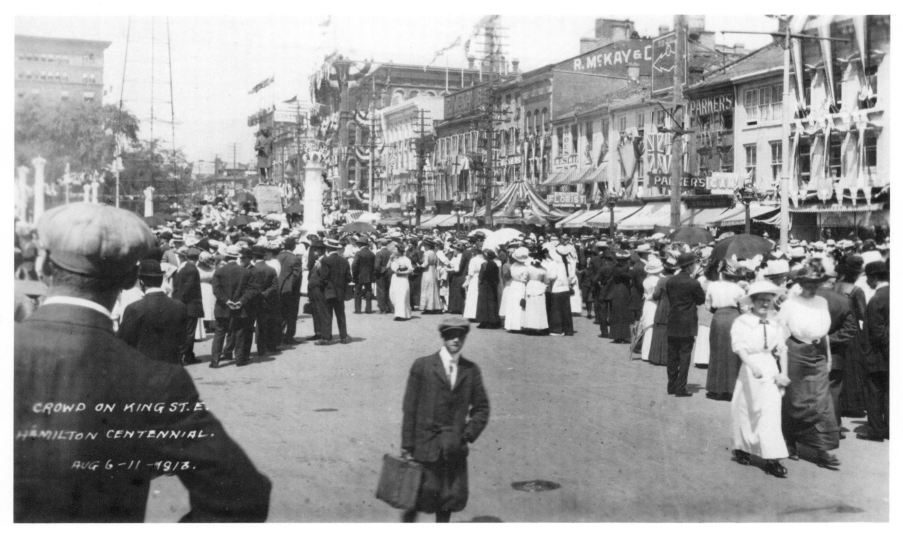

CROWD ON KING ST. E
HAMILTON CENTENNIAL.
AUG 6-11-1913.

62

A time to celebrate. The buildings were well decorated and the streets of downtown Hamilton were crowded as the residents celebrated a special occasion, the 100th anniversary of the founding of the community. This postcard, taken in August, 1913, shows the crowd taking in the festivities on King Street East. That's the Bank of Hamilton off to the left, and the Right House in the centre of the photograph.

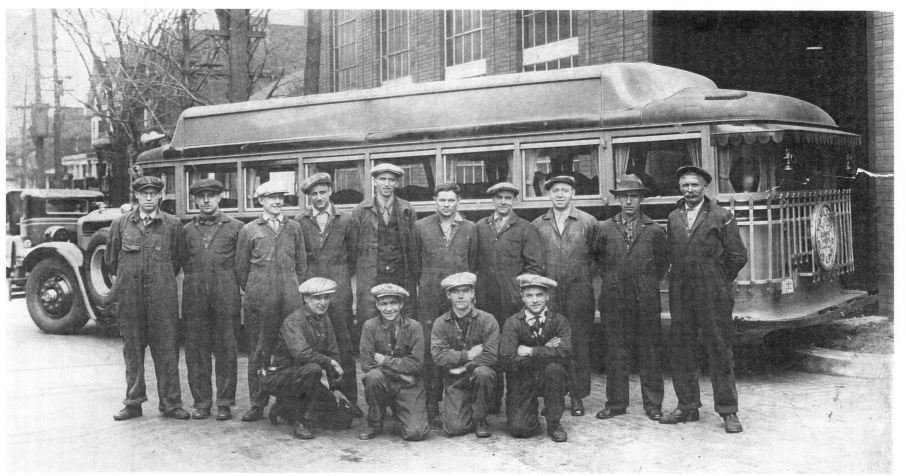

A pose for posterity. The photograph is torn and tattered, and yet it still captures a moment in the life of Hamilton's work-force. Taking a break from their duties, the mechanical staff of the Hamilton Street Railway pose in front of a touring bus parked outside the HSR bus barns back in 1927. Despite the need to protect themselves with cover-alls from the grease and grime of their work, the workers still presented a polished image, with most wearing a shirt and tie. The bus in the background was designed for those long jaunts out of the city, with curtains on the windows, and a spare tire for all those emergencies.

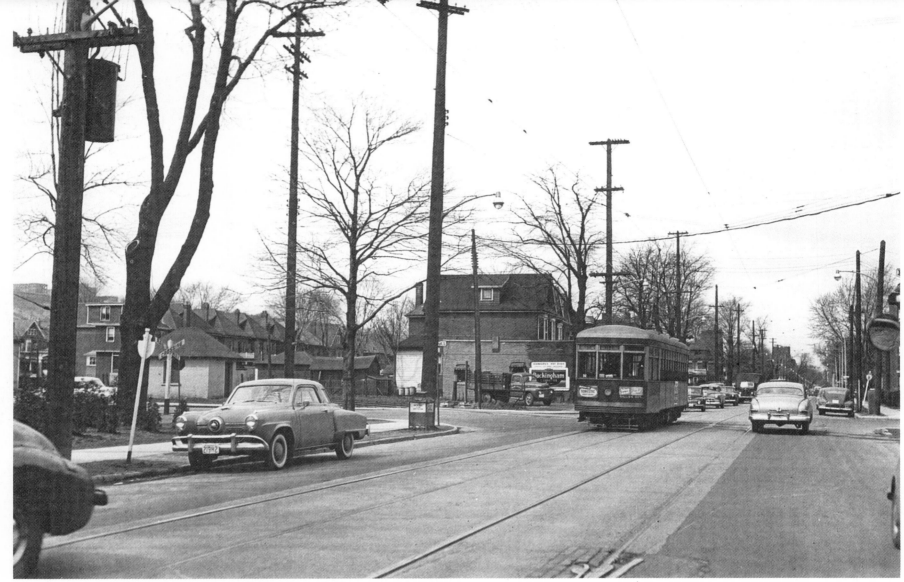

Main East. There was still two-way traffic as well as regular streetcar service along Main Street East when this photograph was taken back in the mid-1950s. The streetcar is just crossing over Gage Avenue, the western boundary to one of the city's more popular parks, the massive Gage Park facility which was purchased back in 1918.

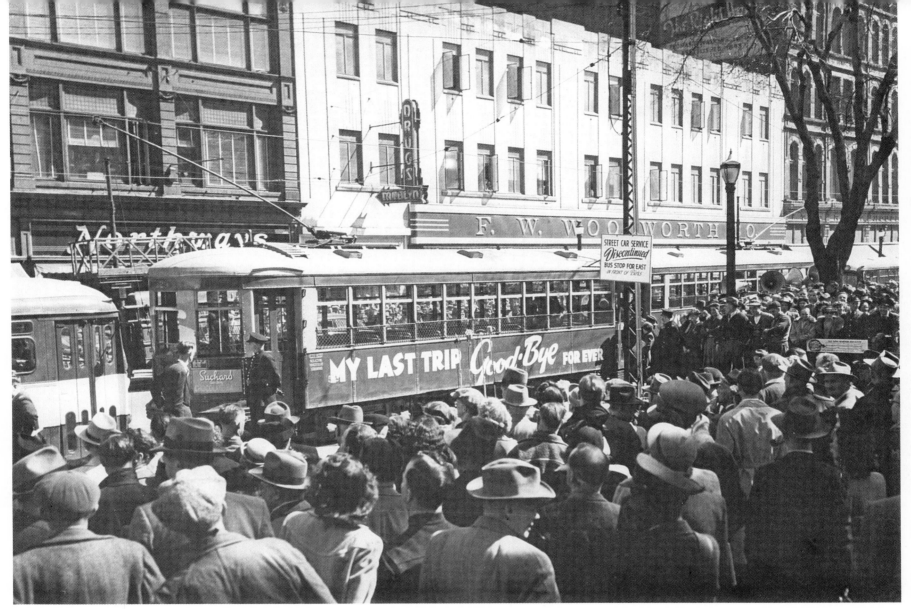

End of the line. There was a huge crowd on hand to witness a moment in history, the discontinuation of streetcar service by the Hamilton Street Railway. The huge sign on the side of the streetcar tells the story, as the crowd gathers in Gore Park to mark the occasion. Streetcar service - the horse-drawn variety - was inaugurated in 1874, and continued until 1892 when the electric trolleys were introduced on city streets. The era of the streetcar service ended in 1951, to be replaced by HSR buses.

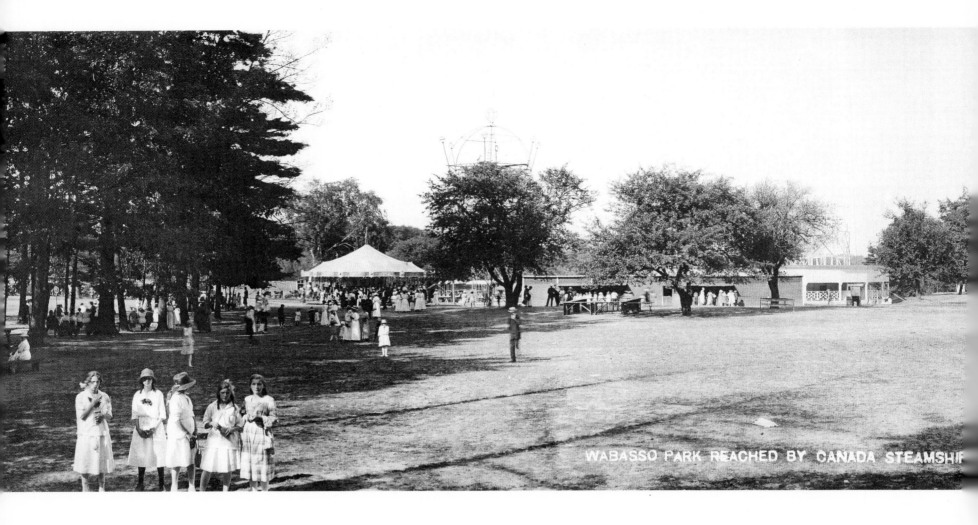

WABASSO PARK REACHED BY CANADA STEAMSHIP

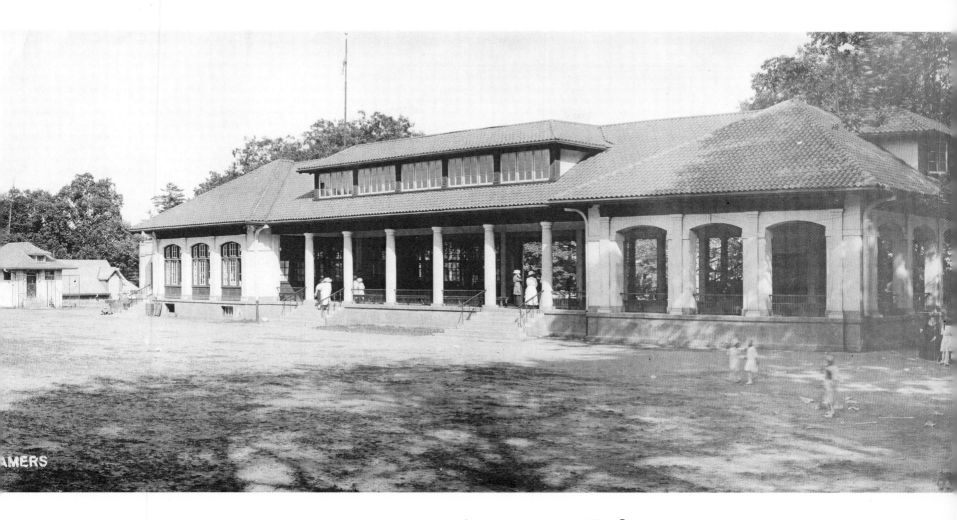

Amusement Park. There is still a pavilion on the grounds today, but the amusement park seen in the background of this photograph of Wabasso Park is long gone, the victim of the Depression and old age. The park, on the shore of Hamilton Harbor, is owned by the city of Hamilton, but is located in Burlington. It was known as Wabasso when this photograph was taken about 1920, and attracted thousands of visitors, with many of them sailing across the bay on a Canada Steamship Line ferry The park was renamed LaSalle Park in 1923, and the pavilion, although destroyed by fire in 1995, has been rebuilt to its original splendor.

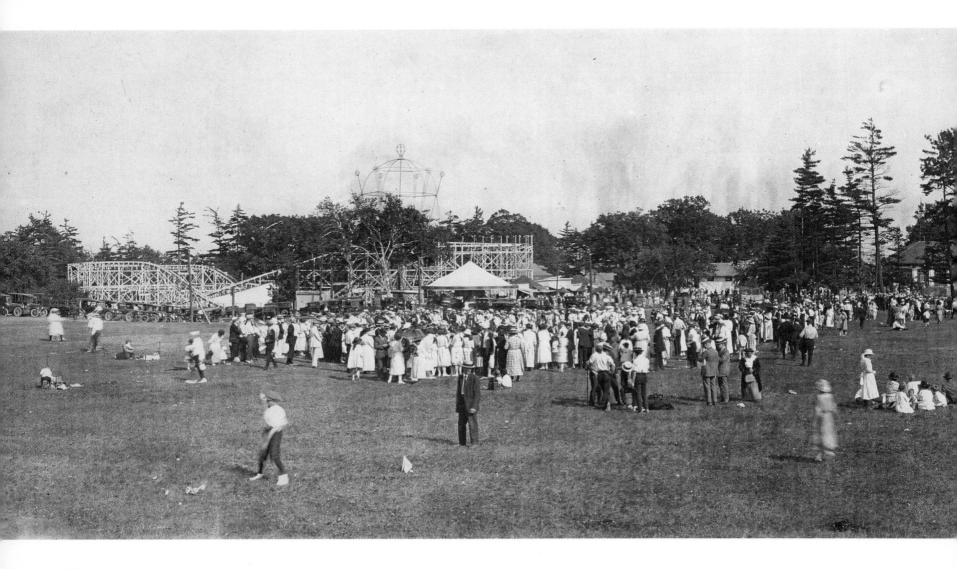

Roller coaster. It may be tame by today's standards, but in the roaring '20s, thrill seekers flocked to this old wooden roller coaster at LaSalle Park. This photograph, taken shortly before the park's name was changed to LaSalle from Wabasso in 1923, shows the roller coaster located just to the east of the original pavilion. At one time, the roller coaster had two sets of cars running simultaneously to accommodate the huge number of people lined up for a ride.

The bus stops here. It's a scene from another era, what with the traffic flowing two ways on Main Street, a Ford and Monarch dealer where one of the city's highest office towers now rises, and with gas stations featuring brands long gone from the scene. The photograph was taken about 1955 from the roof of the Wentworth Motors building at the corner of Main and Catharine streets, where Terminal Towers is now located, and looks east along a busy Main Street. The bus in the foreground is just leaving the Terminal Station lot, the depot for the radial electric railway when it opened in 1907, and from 1933 until 1959, the hub of bus traffic in the city.

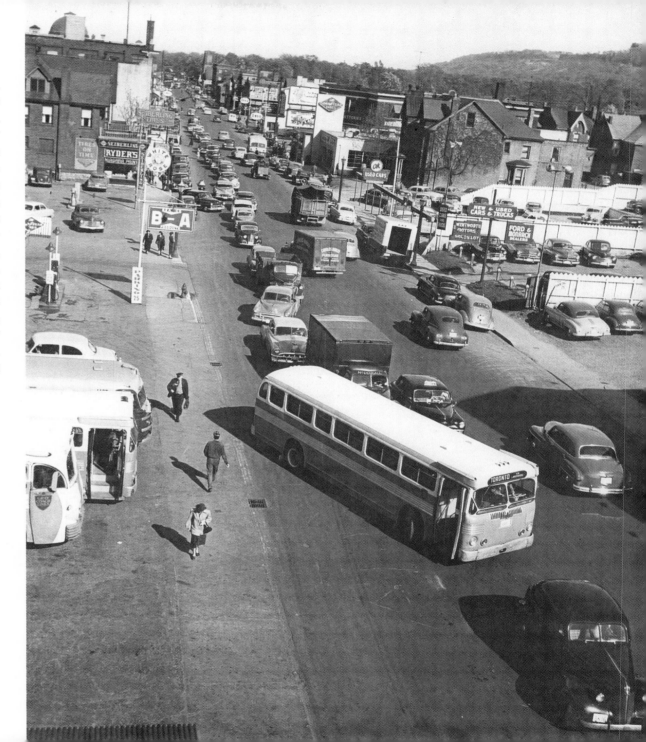

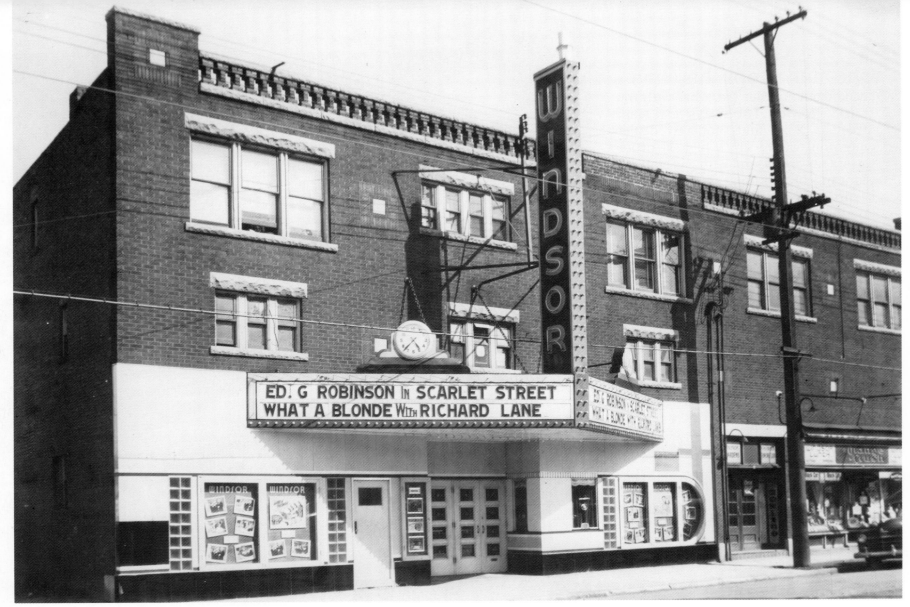

Neighborhood theatre. It was just one of many neighborhood theatres of the day, providing Hamilton theatre goers first-run entertainment such as the Edward G. Robinson feature, Scarlet Street, but today, theatres such as the Windsor on Kenilworth Street have long faded from the scene. This photograph, taken in 1947 as part of the licensing requirements for all movie theatres across the province, shows that the Windsor name was carried over to the Windsor Gardens above the theatre and into the Windsor Lunch located next door to the theatre. Note the street side box office and the clocks atop the marquee.

A Capitol idea. It's just a memory today, but at one time the Capitol Theatre on King Street - shown in this 1947 photograph - was one of the largest theatres in Canada, with seating for more than 2,900 patrons when it was opened on New Year's Eve, 1917. The theatre, which was originally known as the Loew's Theatre, featured many amenities including two broad staircases to the orchestra and mezzanine boxes and three more to the mezzanine floor and balcony. Opened as a vaudeville house, it was demolished soon after the final movie was shown in August, 1971.

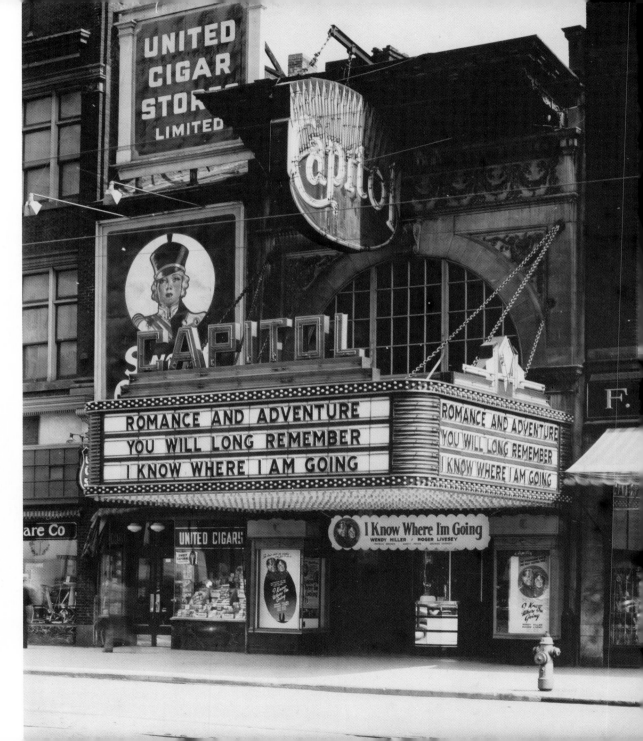

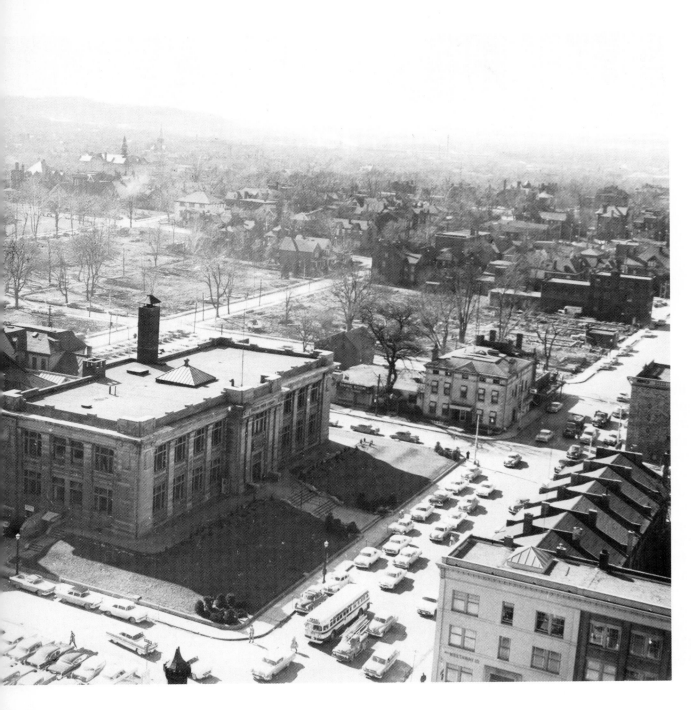

City hall. These two photographs taken from the rooftop of two different buildings show the transition of a huge parcel of land on Main Street from an interesting mix of retail, commercial and residential to the development of Hamilton's new city hall in 1960. The photograph at left, taken from the roof of the Sun Life Building on James Street, shows only a few buildings left in the area bounded by Charles and Bay streets as work progresses to prepare the site for the city hall building. On the right, the photographer climbed to the roof of the Revenue Canada building to take the opposite view, showing work on the new city hall well under way.

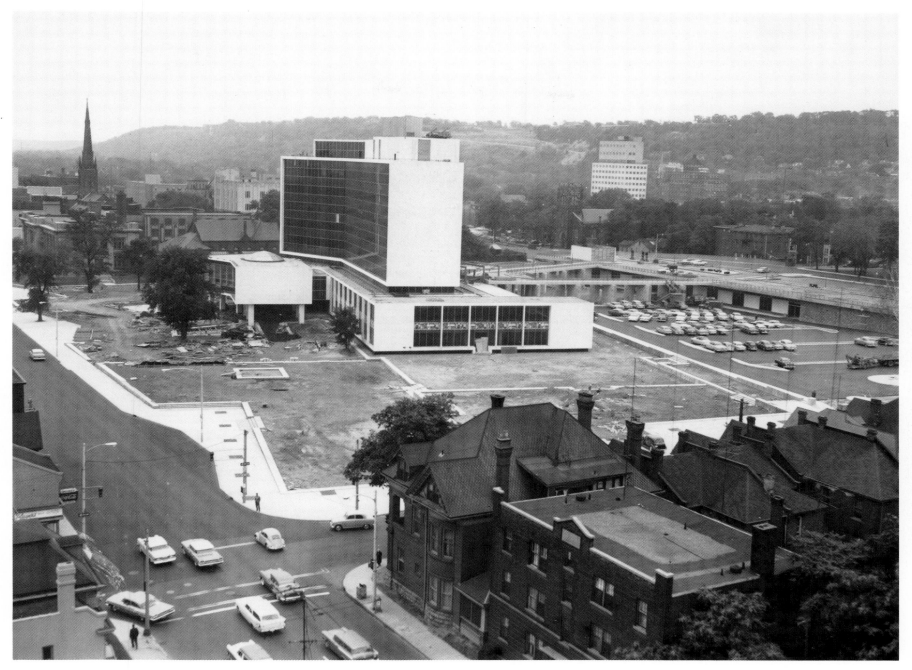

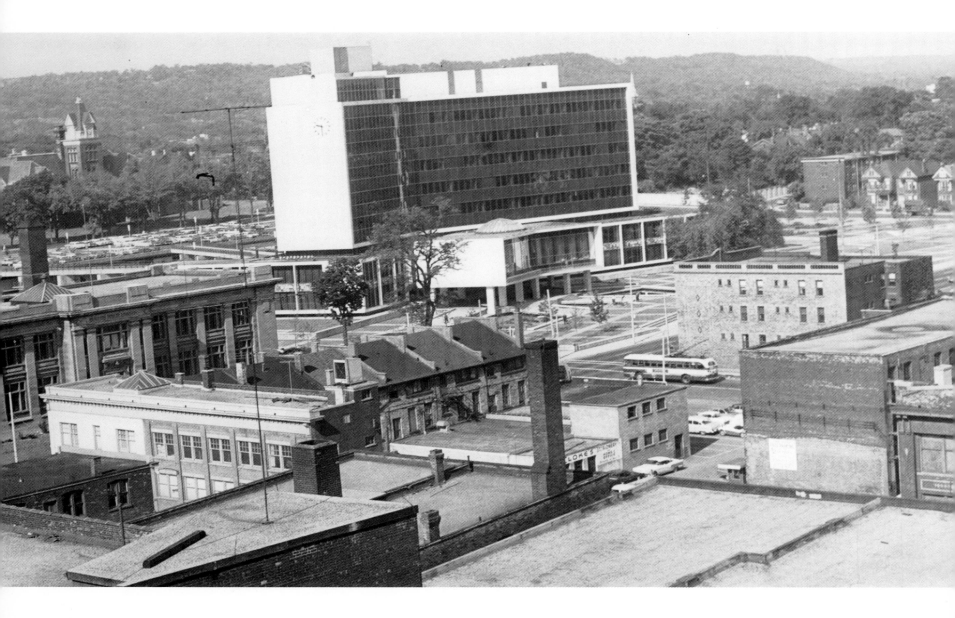

Panoramic view. Usually, when a photographer climbed high atop the CIBC building, it was to photograph King Street East and Gore Park, but in this 1960 photograph, the camera offers this unique look at a vast area redeveloped over the years to the west of the bank building. Two photographs have been joined to capture this panoramic view of the area west of the core, an area which now houses such facilities as Hamilton Place and the Convention Centre as well as office towers.

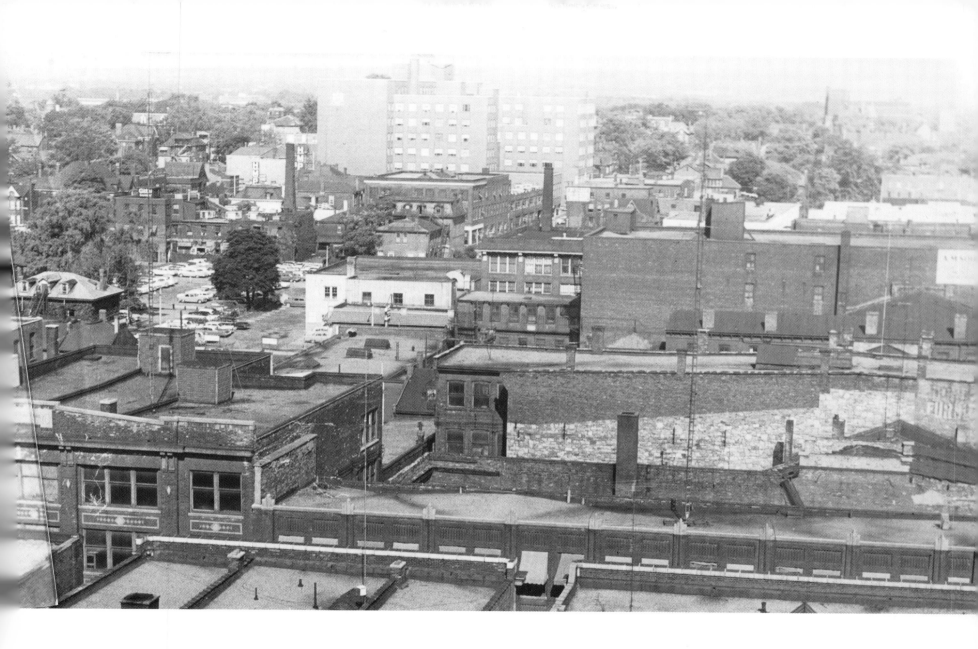

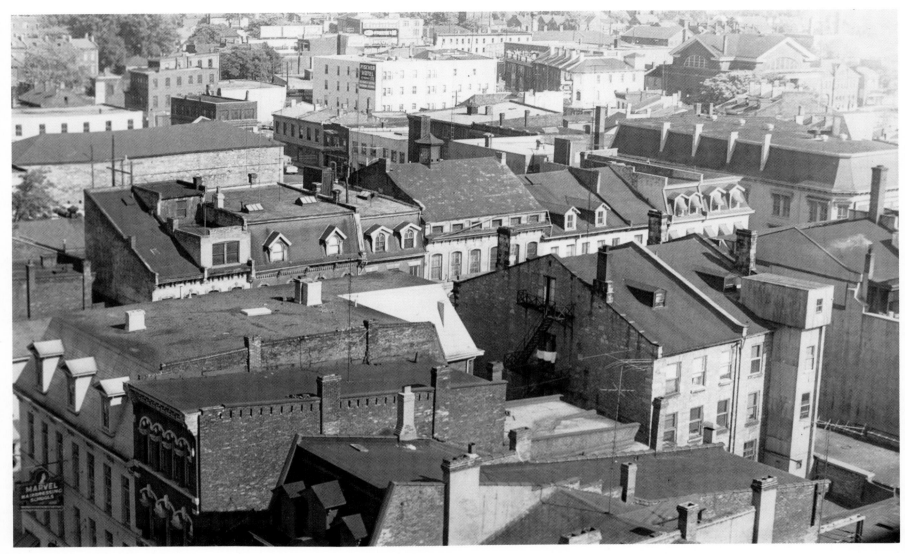

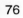

And more of the same. This photograph of the buildings along King Street west of James is a continuation of the scene from the previous page, again taken from the roof of the CIBC building. All the buildings in the immediate foreground were demolished in the 1970s and were replaced with Jackson Square.

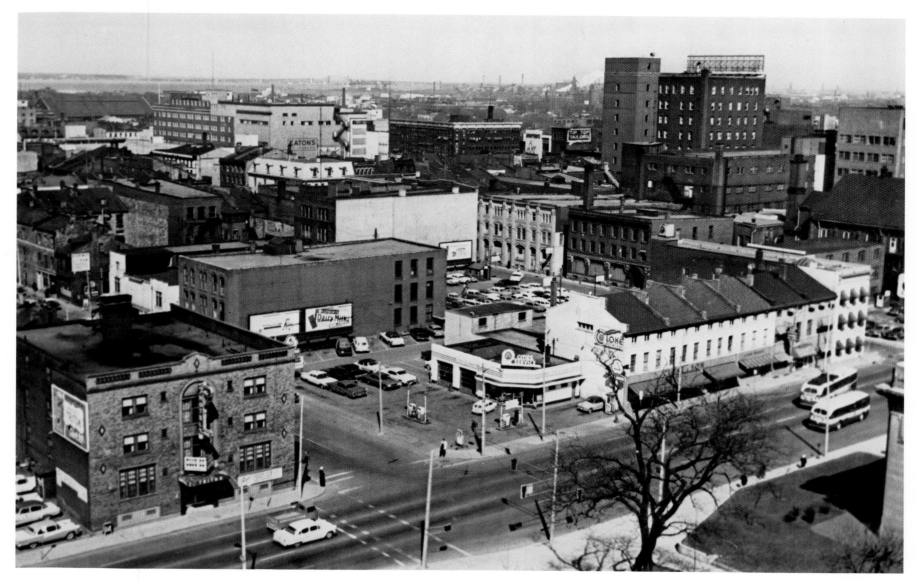

The same, only different. The photographs on the previous pages were taken from the CIBC building with Hamilton's new city hall in stark contrast to the old buildings in the foreground. This photograph is taken from high atop city hall offering the reverse view of the previous photographs, with the CIBC building at top right. An old Cities Service station, at the corner of Charles Street, joins an eclectic mix of businesses just to the west of James Street. Centenary United Church, built in 1868, can be seen to the right, while just a corner of the old Carnegie Library is visible on Main Street.

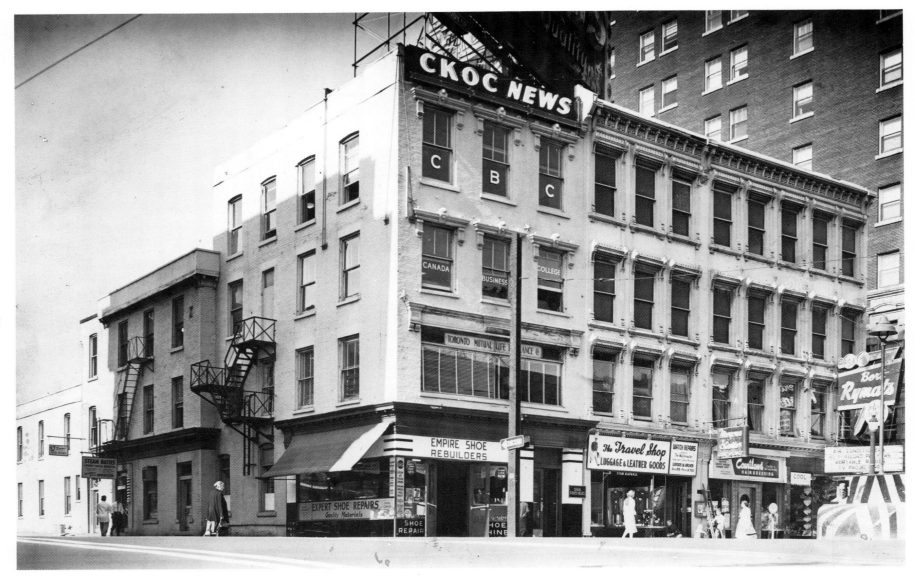

Long gone. It's the site of a parking lot today, but back when this photograph was taken in 1957, the building on the south-west corner of King and Catharine streets housed a number of retail stores and offices. Located right next to the Royal Connaught Hotel, the building had everything from a shoe **repair to the local CBC office, and tucked in the back corner, a steam bath.**

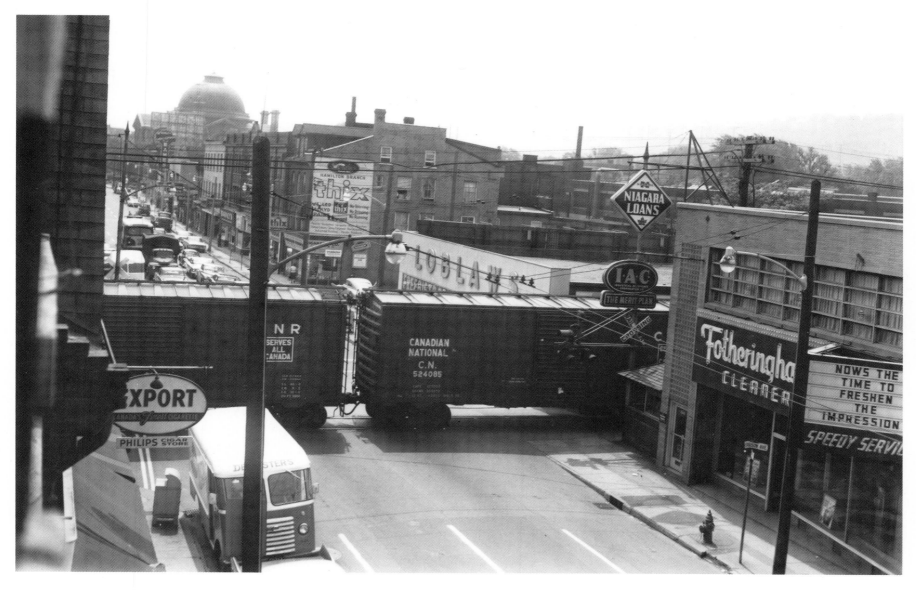

Traffic stopper. Traffic came to a standstill, and waited, and waited, as freight trains at one time rolled across King Street, blocking traffic into the downtown core before the tracks were finally taken up. Here a freight train rumbles through the heart of the city in 1961, while traffic starts to back up towards Wellington Street. Many of the old retail shops along that stretch of King Street are visible here, while off in the distance is the dome of First United Church, destroyed in a fire in 1969.

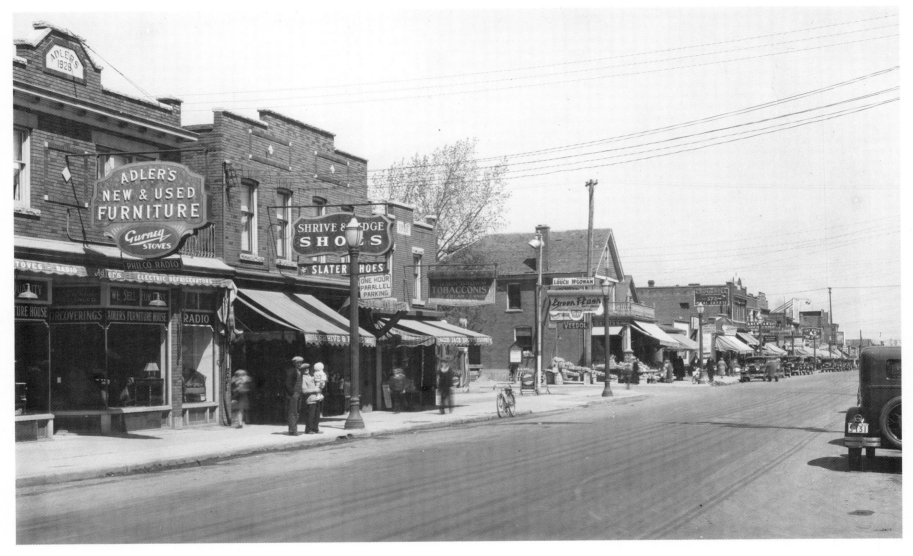

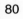

Ottawa Street. If one takes a close look, some of the buildings in this photograph of Ottawa Street North are still part of the streetscape today, but the names on the store fronts are long gone. The photograph was taken in 1933, showing the west side of the street, looking north, near the intersection of Campbell Avenue. It was a most diversified street at that time, with a fruit stand at the corner, shoe stores, ladies wear, a drug store, tobacconists and of course Adler's Furniture drawing shoppers to the east end street.

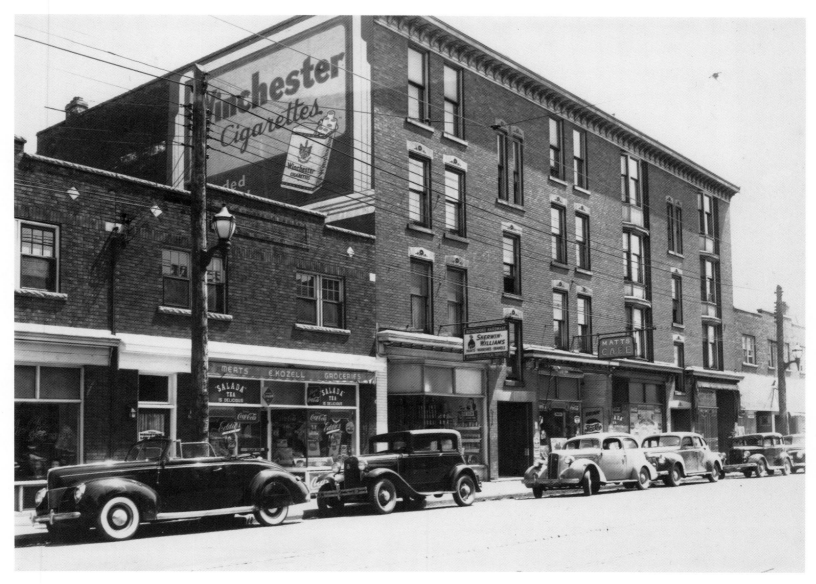

Barton Street. One look at the cars along Barton Street dates this photograph back to the late 1940s, a time when stores such as Kozell's Groceries, Rutherford Hardware and the Chic Hat Shoppe provided a focal point for the shoppers from that part of Hamilton. Note the unique street lights half-way up the poles.

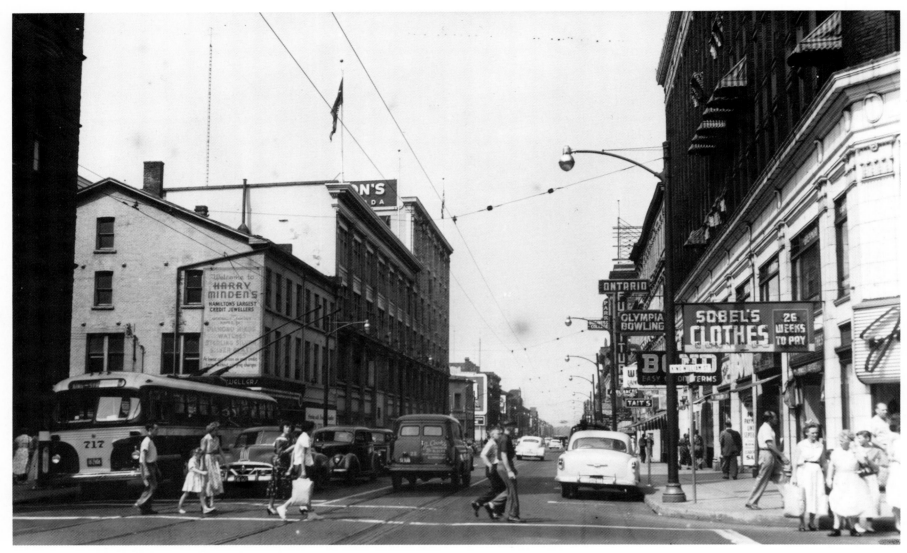

Another era. The Eaton company had yet to expand, there was two-way traffic on James Street North, and the old city hall was still standing when this photograph - looking north from King William Street - was taken in the early 1950s. Eaton's would later expand, taking up the entire area to the left of this photograph. The Lister Block, to the right, housed a variety of retail and office establishments before it was boarded up, waiting for redevelopment.

King William. There were a great many photographs of Hamilton's old city hall taken over the years, but few of them were taken from along King William Street showing how the magnificent clock tower dominated the streetscape. In this 1950s photograph, a winter's snow has fallen on the street as vehicles inch both ways along what is now a one-way street. The city hall building was demolished in 1961 following the construction of a new building on Main Street. That's the Lister Block at the corner of James Street along with Martin's Sports Centre and Turner Wines, two stores which had a long history on the street.

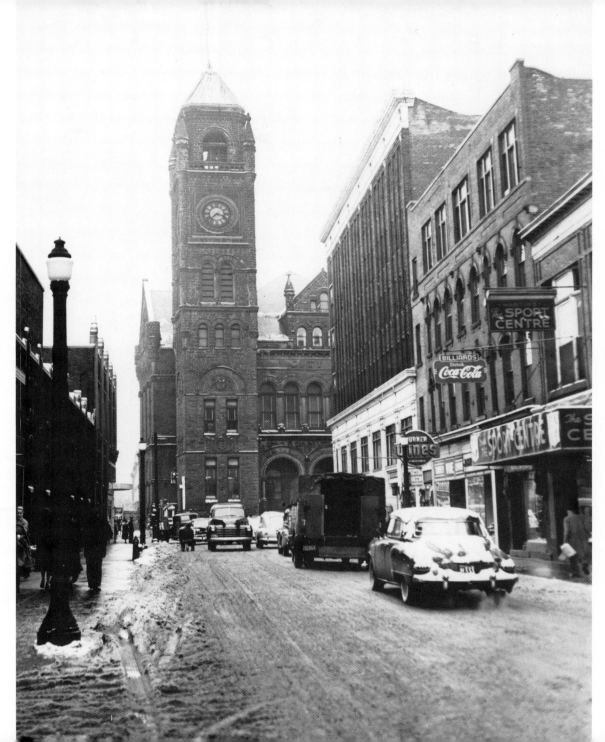

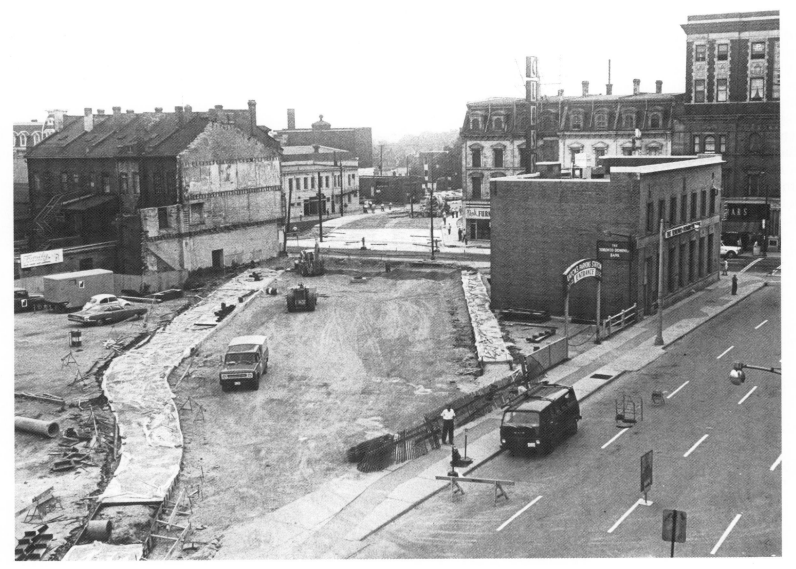

84

Banking on an island. No, it has nothing to do with off-shore banking, but when Merrick Street was re-aligned in 1970 to join up with Wilson at the corner of James Street, the Toronto-Dominion Bank was left on an island between two streets. The archway behind the bank indicates the entrance to the Eaton's parking garage which was demolished to make way for the new street.

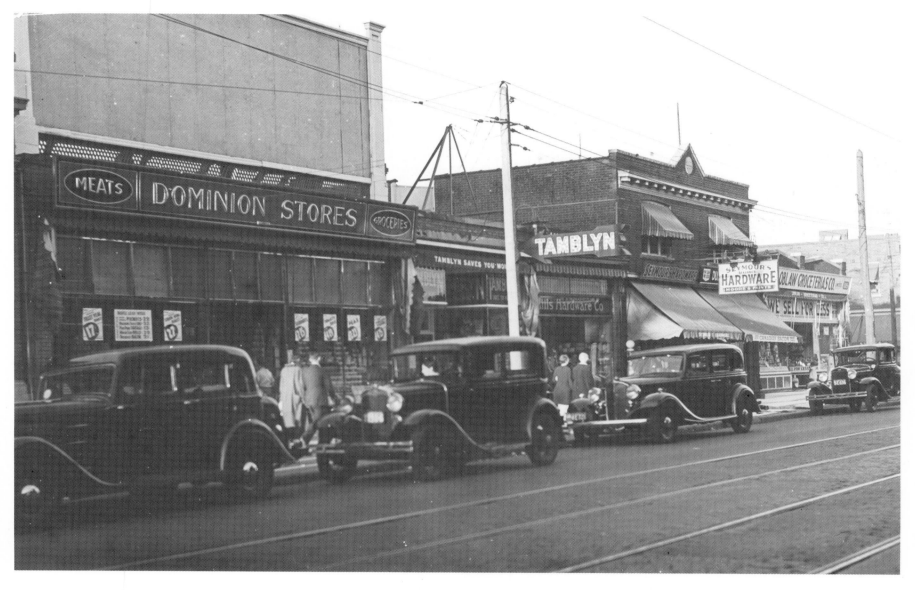

Shopping district. There was quite a little shopping district on Main Street East around the Delta back before the Second World War as can be seen from this photograph taken in 1937. The Dominion Stores and Loblaw Groceteria both had a presence doors apart, and were joined by two hardware stores, a drug store and a butcher shop.

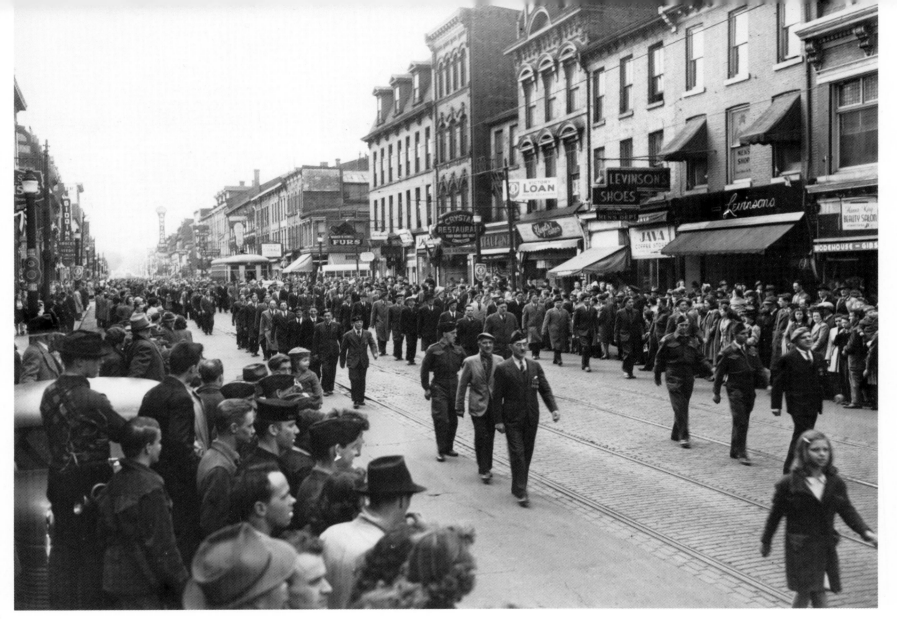

Victory. Everybody loves a parade, especially when the parade marks the end of six years of war. That was the case with the parade above, as city residents jammed King Street West for the march from Victoria Park to the city centre as part of the VE Day celebrations. The photograph, from the May 8, 1945 edition of the Hamilton Spectator, shows the huge crowd lining both sides of King Street for this **happy occasion**.

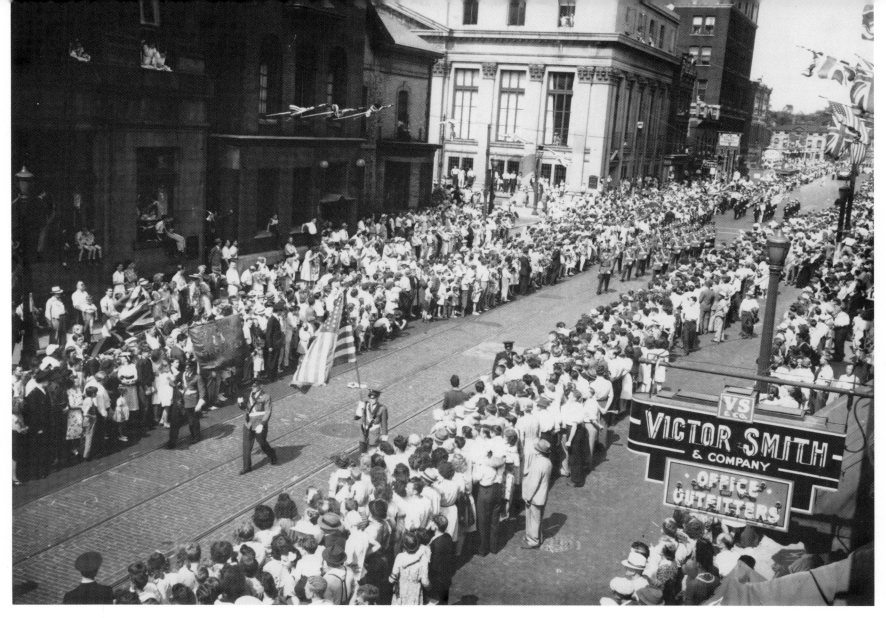

Centennial parade. Just one year after the big VE Day celebration as shown on the opposite page, the citizens of Hamilton were once again out in huge numbers, this time to celebrate the city's 100th anniversary in July, 1946. The city was in a festive mood for several weeks, with numerous special events to mark the occasion, including the Centennial parade, shown here as it crosses James Street as it moves eastward along Main Street.

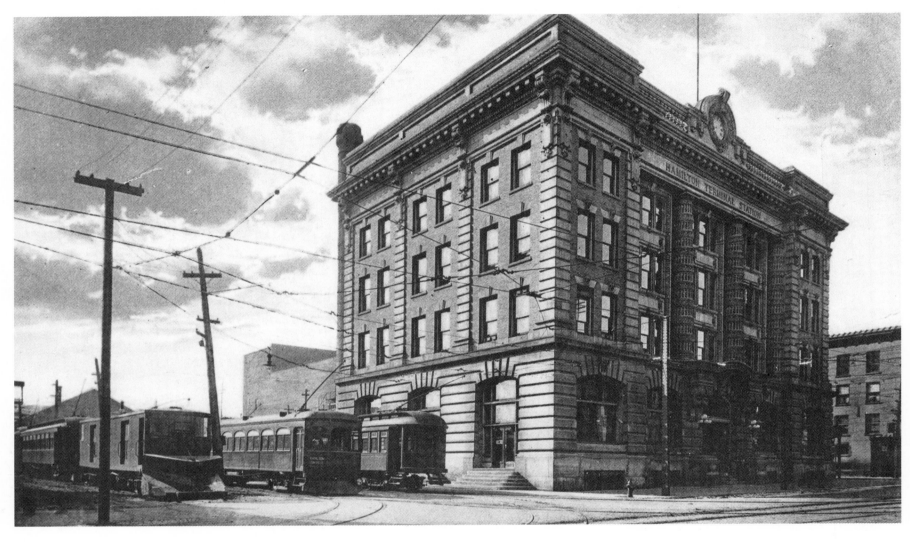

Terminal Station. It was once called one of the most elegant electric railway stations on the continent, occupying a strategic location on the south-east corner of King and Catharine streets. The Terminal Station would serve an extensive network of electric railway lines for 20 years after it opened its doors in 1907, and would later serve as the city's main bus terminal. The building, shown here in this early postcard, was demolished in 1959 with the site today occupied by the Terminal Towers building.

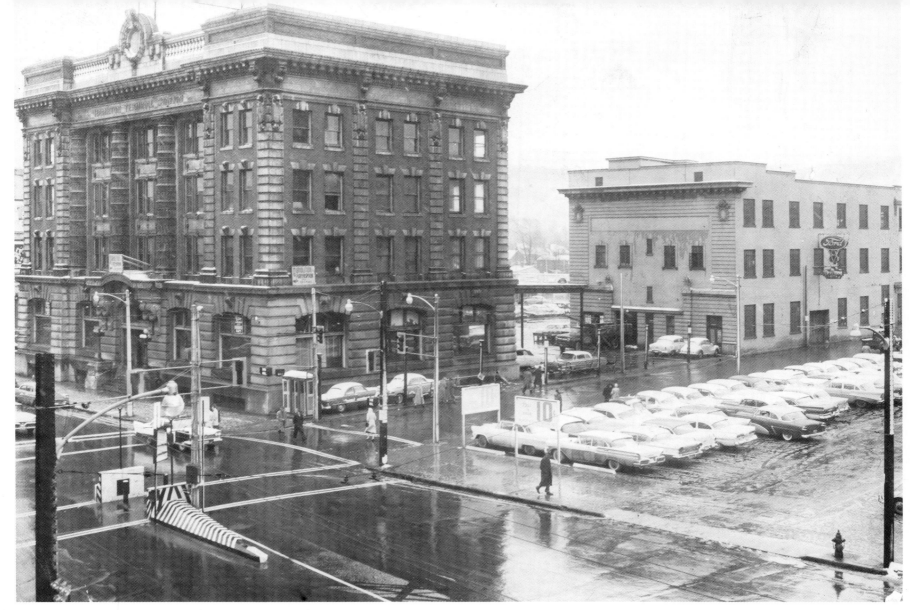

Date with the wreckers. It was shortly after this photograph was taken in 1958 that the Terminal building had a date with the wrecking crew. But in addition to giving a different view of the historic old building, this photograph shot from the old Hamilton Spectator building on King Street East shows Wentworth Motors located at the corner of Main and Catharine streets. Parking at the lot next to the Connaught was a most popular spot, with the rate set at 10 cents for the first half hour.

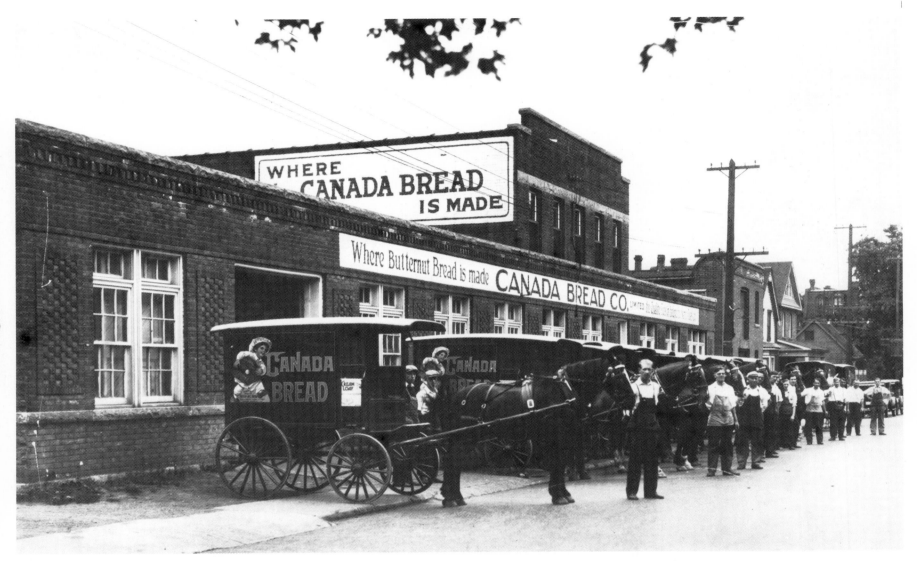

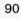

Bread wagons. There was a day, a long time ago, when the bread wagon was a common sight on the streets of Hamilton. There were numerous bread companies making the rounds of city streets, delivering bread and bakery products right to the door, but one of the biggest was the Canada Bread company, with just part of their fleet of wagons shown here in this classic pose with the drivers and horses ready for a day's work.

Etched in history. It was one of those moments frozen in time, and it happened before a huge crowd of roaring fans at Ivor Wynne Stadium. With no time left on the clock, Tiger-Cat place-kicker Ian Sunter split the uprights, giving the Tabbies a thrilling 13-10 victory over the Saskatchewan Roughriders in the 1972 Grey Cup game. Moments after the game, Angelo Mosca, for many years the anchor of the defensive line, and always a crowd favorite, saluted the fans with the Grey Cup, a photograph which has been etched in the minds of Tiger-Cat fans since that November day.

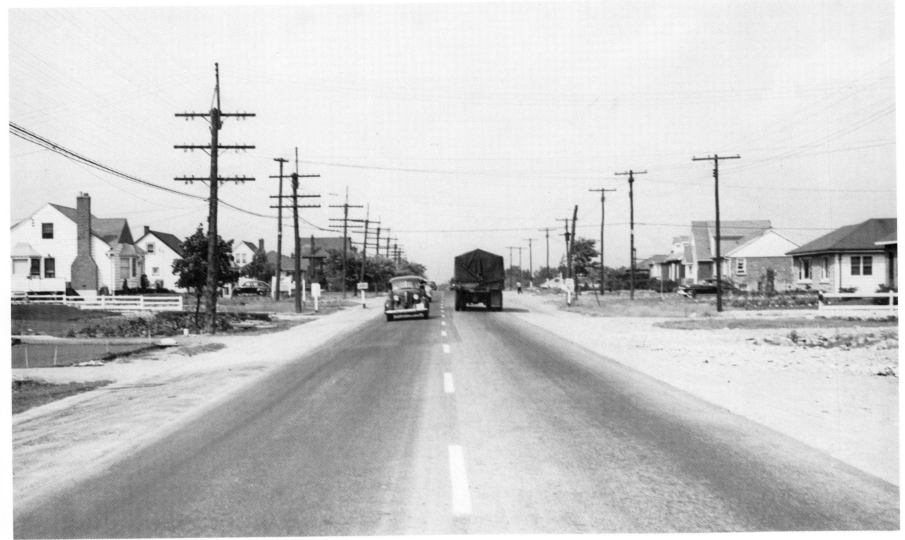

Along James. Today, this stretch of road is one of the busiest thoroughfares in the city, but when this photograph of Upper James Street was taken in the summer of 1952, it was anything but busy. It was just a two-lane road in those days, with a wide road allowance to accommodate future development. The photograph was taken just south of Fennell Avenue.

Grand old house. Built in 1876, this magnificent house at 275 James Street South was just one of many mansions located in this part of the growing city. The house was built for W. F. Lea, who called it Clova Lea and when he later sold it to Col. Henry McLaren, it was renamed Balquidder. After several other owners, it was occupied by No. 119 Bomber Squadron in 1937, and later became a recruiting centre. In 1945, it was sold to the Dominion Government for use by the RCAF, but was later demolished to make way for the expansion of St. Joseph's Hospital.

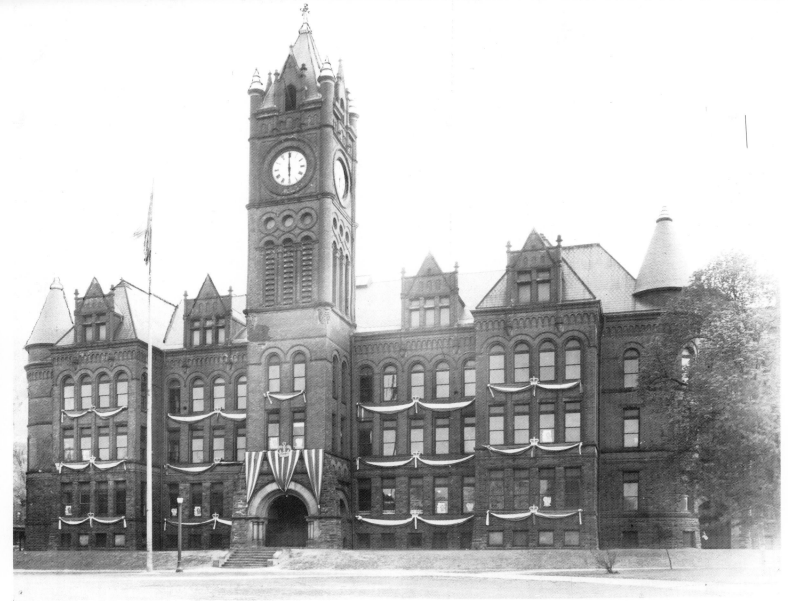

Dressed up for a king. It was a time for a celebration as Hamilton prepared for the coronation of King George VI in 1937, with Central Collegiate one of the focal points to mark the occasion. The huge school, at Hunter and Victoria streets, was completed in 1897 at a cost of $155,000, and served as the city's only facility for high school students for many years. The building was reduced to a blackened shell in 1946 after a fire ravaged the three storey school and its magnificent clock tower.

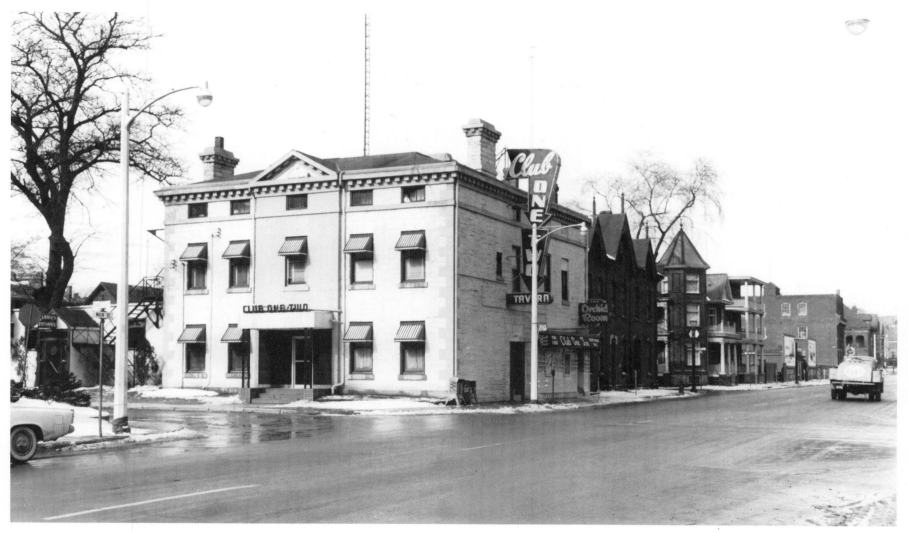

Last call. It was one of the final landmarks to go when a vast area of Main Street was demolished in 1958 to accommodate Hamilton's new city hall. The Club One/Two occupied a site on the south-west corner of Main and Charles streets facing the old Carnegie Library. In this picture from the early 1950s, the photographer portrays Main Street looking to the west, showing a number of other buildings which were demolished for the city hall plaza.

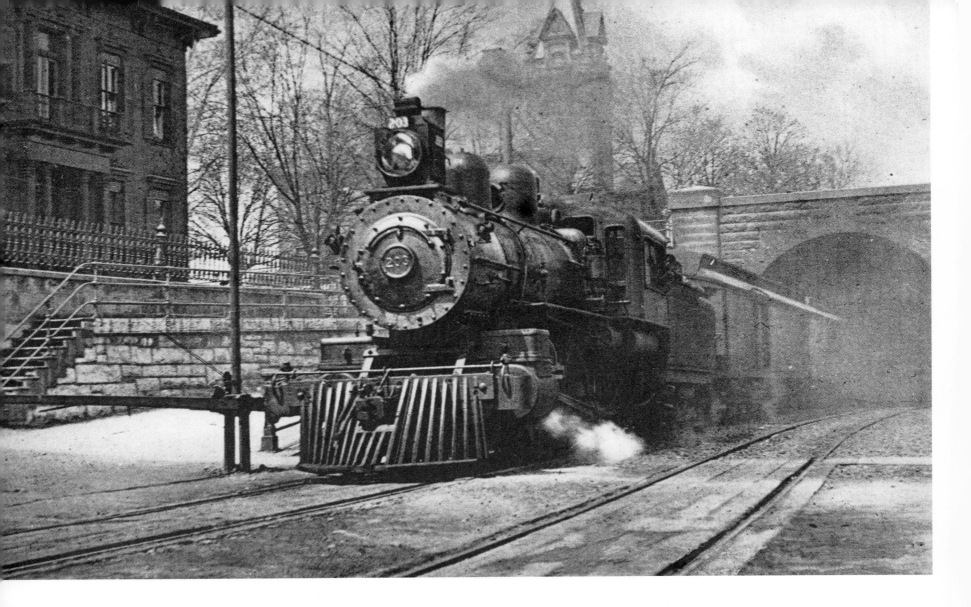

Steaming into Hamilton. The city of Hamilton has been well served by railway lines over the years, with the Great Western Railway providing service as early as 1854. But while that line was welcomed with open arms, the building of the Toronto, Hamilton and Buffalo line was met with much controversy when the decision was made to tunnel under Hunter Street from Queen through to Park so as to not disturb many of the fine houses in that area. The building of the tunnel was a construction nightmare as the construction crew raced against the clock to secure a $250,000 bonus for meeting a Dec. 31, 1895 deadline. The deadline was met, and over the years, countless freight and passenger trains, such as the early one pictured here, have chugged through the tunnel.

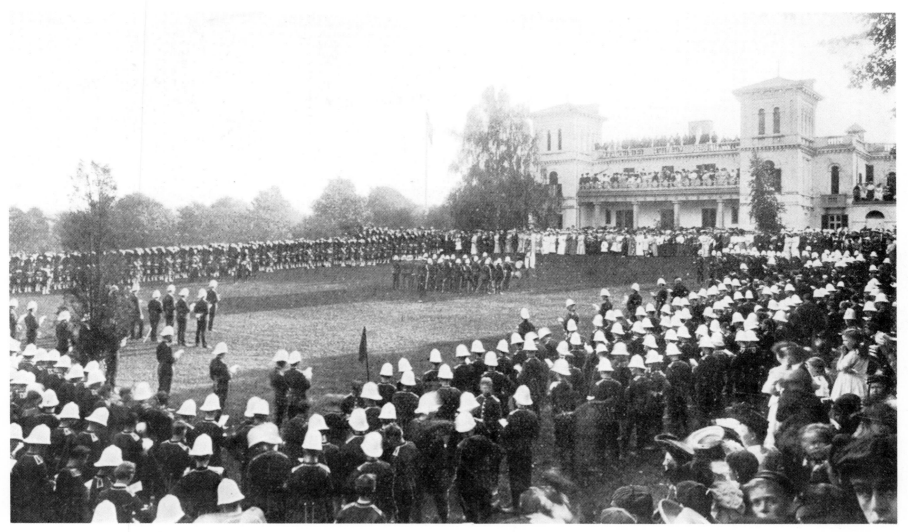

Church service. Most of the photographs of Dundurn Castle are taken from the front of Hamilton's oldest building, but in this case, the rear of the building is shown as part of an impressive church service in Dundurn Park. Taken in about 1912, the park is ringed by members of the militia, while scores of people took to the castle's balcony and even its roof to participate in the service.

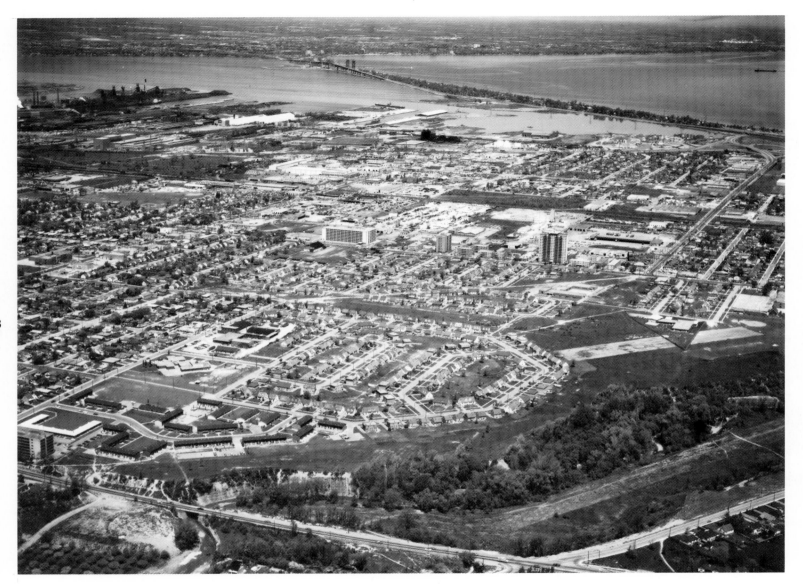

Aerial view. It was a popular spot for years, with many young flyers getting their wings at the east-end airport, but with the gradual development, the land was eventually turned into housing developments. This aerial photograph, taken in the 1960s, shows the development encroaching on the landing strip in the bottom right, with one of the runways still visible. Off in the distance is the Beach Strip, with the Burlington Skyway Bridge soaring high above the canal.

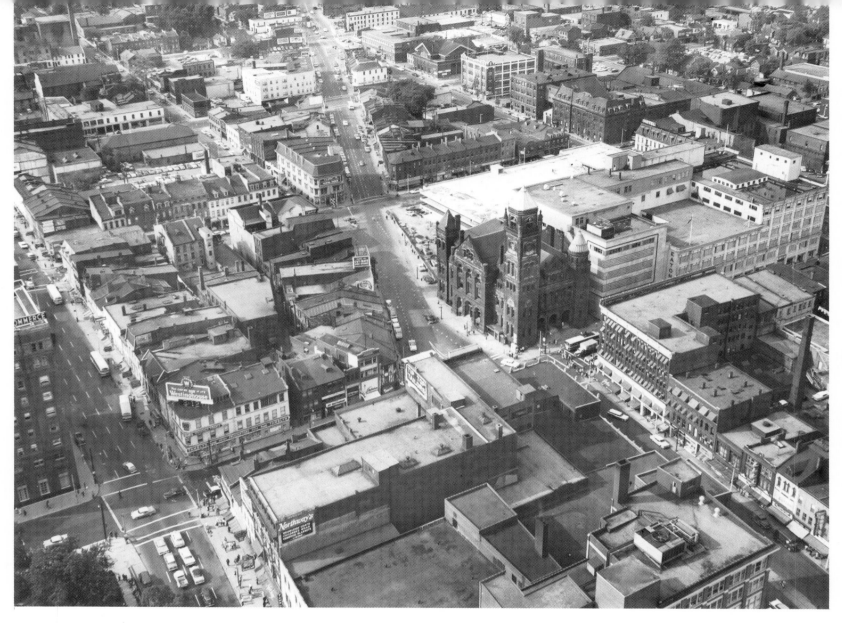

City centre. It was just removed from the key inter-section of the city, but for many decades the pulse of the city could be felt at James and York, the location of Hamilton's majestic city hall before it was re-located to Main Street. The old city hall can be seen here in this late 1950s aerial photograph, with the huge Eaton's complex to its right. There are a number of streets west of James Street which although visible in this aerial photograph, are no longer on the city map with the street system having been re-aligned over the years.

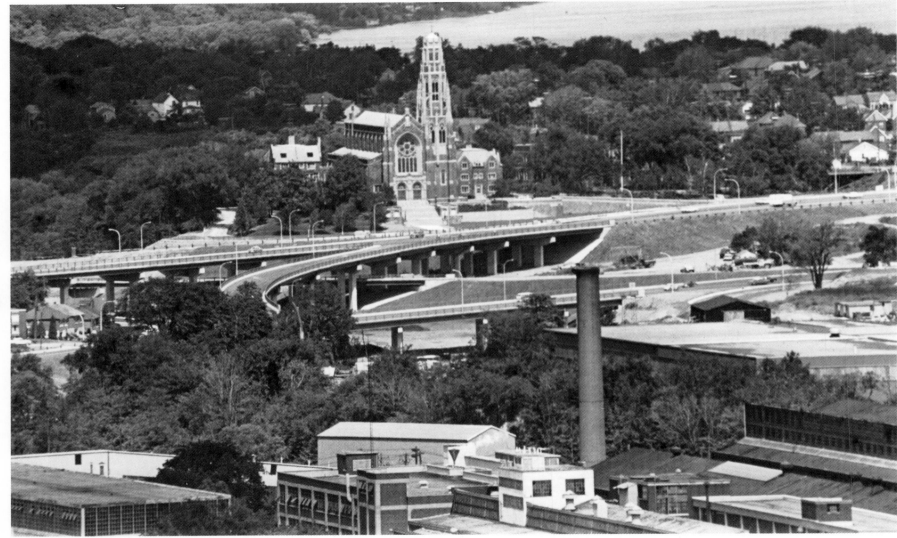

Cathedral. It's one of the best known landmarks in the city of Hamilton, but this unusual view of Cathedral of Christ the King offers a different perspective of the massive church on King Street West. There is no date on this photograph, but with the two-way traffic on King Street, and the road work under way in the area, it probably dates from the early 1950s. That large body of water behind the church is the western end of Hamilton Harbor.

Lighthouse. Usually, photographs of lighthouses are taken from the ground up, but in this case the photographer obtained a most unusual vantage point to capture this view of Hamilton's old lighthouse on the Beach Strip. Riding up on the lift bridge back in the early 1960s, the photographer shows the magnificent stone work on the 90-foot high structure. The lighthouse dates back to 1858, replacing an even earlier structure which was destroyed by fire. Located in the shadow of both the lift bridge and the Burlington Skyway Bridge, the structure is almost indestructible, what with its cellar walls more than seven feet thick. The historic lighthouse was abandoned in 1961 with a modern beacon at the end of the pier now guiding ships into the harbor.

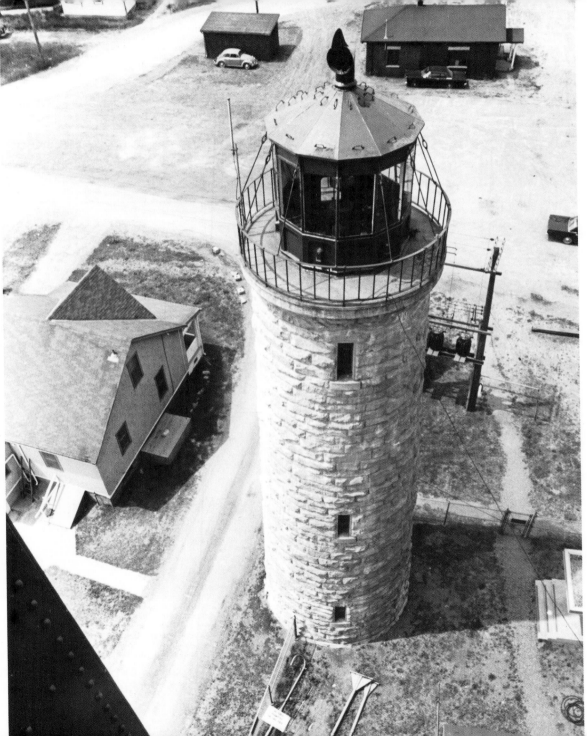

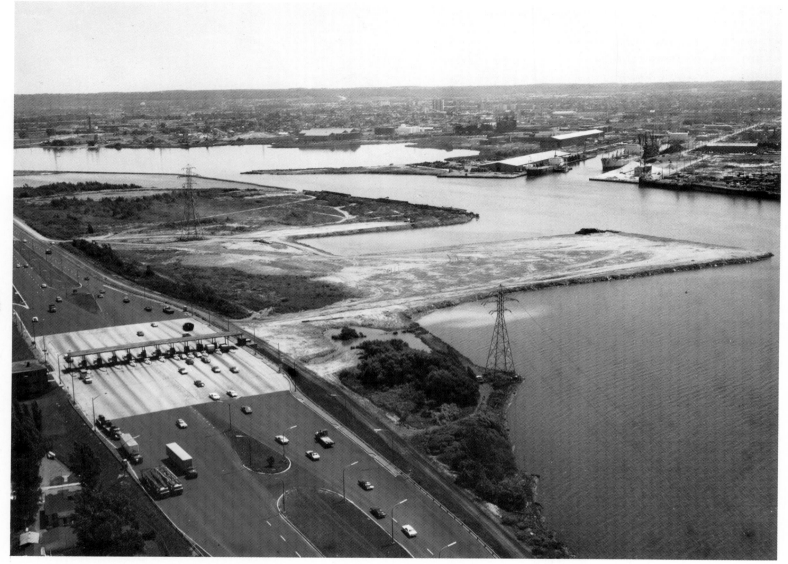

Toll booths. When the Burlington Bay Skyway Bridge was completed in 1958, Queen's Park decided that tolls - at 15 cents per trip for cars - would be charged to help defray the cost of Ontario's longest and most expensive bridge, a $17 million structure over the ship canal. The toll booths at the southern end of the bridge can be seen here, with part of the Hamilton waterfront and east Hamilton off in the distance. The tolls stayed in place until 1973.

Summer fun. Hamilton's lakefront has always been a magnet for those seeking fun in the sun, but a new element to this enjoyment was added in 1960 when the huge Lakeland Pool was built along the edge of Lake Ontario. In this early photograph of the pool, parking is at a premium on a hot summer day as swimmers flock to the lakeside pool, while others enjoy a cool dip in the lake. But it wasn't just the pool which attracted people to the beach, as fun-seekers flocked to the amusement rides, the arcade and the trampoline.

About Gary Evans

Gary Evans has been in the publishing business, in one form or another, for 39 years, working for newspapers in various parts of Ontario including 25 years with The Hamilton Spectator.

He has produced a number of books in recent years, including Norma Bidwell's The Best of Stoveline, the Grand Old Buildings of Hamilton, and Brian Henley's 1846 HAMILTON, which was published for Hamilton's Sesquicentennial year.

In addition to The Prints of Hamilton, he compiled The 1995 Hamilton Almanac, The Prints of Time, The Prints of Paradise, The Prints of Burlington and the highly successful Front Pages.

An avid researcher and historian, he now operates his own publishing company, North Shore Publishing Inc., out of Burlington and is currently working on several other books of special interest to the Hamilton market.